7 SECRETS

FROM

HINDU
CALENDAR ART

Devdutt Pattanaik is a medical doctor by education, a
leadership consultant by profession, and a mythologist by
passion. He writes and lectures extensively on the relevance of
stories, symbols and rituals in modern life. He has written over
fifteen books, which include *7 Secrets of Hindu Calendar Art*
(Westland), *Myth=Mithya: A Handbook of Hindu Mythology*
(Penguin), *Book of Ram* (Penguin), *Jaya: An Illustrated Retelling
of the Mahabharata* (Penguin).
To know more visit devdutt.com

7 SECRETS
FROM
HINDU
CALENDAR ART

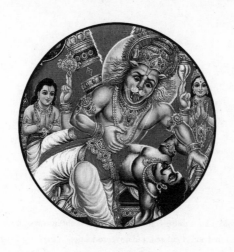

DEVDUTT
PATTANAIK

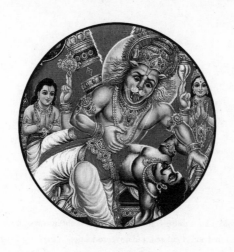

westland publications ltd

61, II Floor, Silverline Building, Alapakkam Main Road, Maduravoyal, Chennai 600095

93, I Floor, Sham Lal Road, Daryaganj, New Delhi 110002

First published by westland ltd 2009

This edition published by westland ltd 2016

This edition first published by westland publications ltd 2017

Copyright © Devdutt Pattanaik 2009

10 9 8 7 6

ISBN: 9789386224026

Typeset and designed by Special Effects, Mumbai

Printed at Thomson Press (India) Ltd.

I humbly and most respectfully dedicate this book to those hundreds of artists and artisans who made sacred art so easily accessible to the common man

CONTENTS

AUTHOR'S NOTE

The images in the book have been picked up from the street, from vendors who sit outside temples and sell their wares to pilgrims. Art historians have explained the origin of these images — how artists like Raja Ravi Varma and the printing technology of the 19th century ensured that these illustrations reached almost every Hindu household across India, and how they came to dominate the visualisation of the common man's faith. In recent times, foreign tourists have been captivated by their supernatural content and gaudy colours. Fashion gurus have used them on the catwalk, incorporating them on apparel and accessories to get the attention of consumers, collectors and the media. But few have stopped to think about them — where does this imagery come from? What are they saying? And, in ignorance, often innocence, sacred art has become fantasy art, used by some in ways that others consider disrespectful.

Attempts to explain the 'fantastic' imagery are usually either defensive, apologetic or chauvinistic, as one tries to legitimise the content using logic or comparisons with other religions. Faith can never be scientific and words like 'sin' and 'prophet' do not help in understanding the worldview of Hindus.

To best appreciate Hindu art, one has to enter a new paradigm, a new way of explaining things. One has to explore new notions of perfection and possibility, quite different from the more familiar and more popular Greek, Biblical or Oriental

worldviews. This book is an attempt to introduce the reader to this new paradigm.

The book consciously uses black and white renditions of the art so that the colours do not distract the reader from the content. Great attention has not been paid to the quality of the images as the point of the book is not the aesthetics of the image but the translation of this unique visual vocabulary created by our ancestors. I would have loved to list down and acknowledge each and every artist and printer; however, tracing them is virtually impossible since the images are not only mass-produced, but also constantly reproduced with minor changes by different artists; often, the same image is brought out by different printers.

Finally, like all things Hindu, the explanations in this book are just one of the many ways in which this art can be looked at. Read this book, keeping in mind:

Within infinite myths lies the Eternal Truth
Who sees it all?
Varuna has but a thousand eyes
Indra, a hundred
And I, only two.

1
GANESHA'S SECRET
Different people see God differently

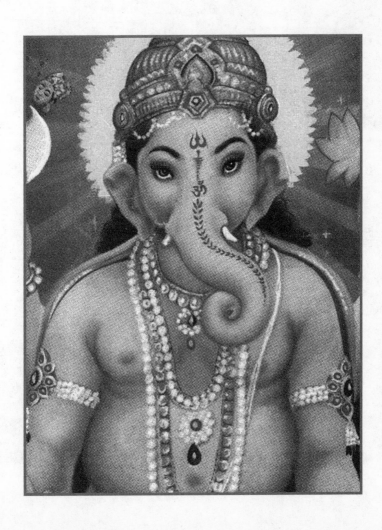

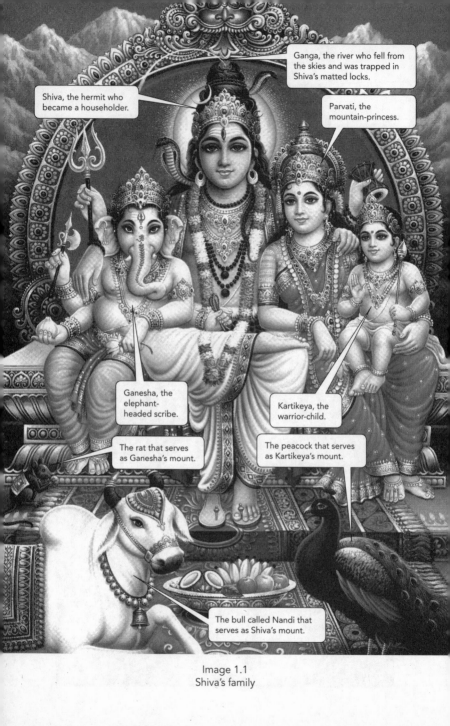

Image 1.1
Shiva's family

Image 1.1 looks like a family photograph: father, mother and two sons. But this is no normal portrait. This is the image of a God called Shiva, a mountain mendicant, his wife, the Goddess Parvati, who is a mountain princess, and their two children, Ganesha, who has the head of an elephant, and Kartikeya, who holds a spear.

An outsider unfamiliar with Hinduism may find these images strange. How can someone have a river flowing out of his hair? How can anyone have an elephant-head and four arms? How can anyone ride a peacock? How can these be presentations of God? And how can there be so many Gods?

But Hindus are comfortable with these concepts because they have been raised with these images, accepting them without feeling the need to rationalise them. These are images of their faith, transmitted over generations. Through them, Hindus are introduced to the notion of the divine. The Hindu notion of the divine is unique. Unlike in Islam, it is given form, which can range from plants to animals to human beings. Unlike in Christianity, it is not restricted to a singular idea — there are gods and goddesses, who are individually pieces of a jigsaw puzzle called God.

A story perhaps best explains this: One day, when this family was sitting together, they were paid a visit by a sage called Narad, who loved to stir trouble wherever he went.

'I have a mango,' said Narad, 'for your better son.'

'How can I decide which one is better?' asked Shiva, turning to his wife, Parvati.

'Let them go on a race,' said Parvati. 'He who first goes around the world thrice shall get the mango.'

'Let it be so,' said Shiva.

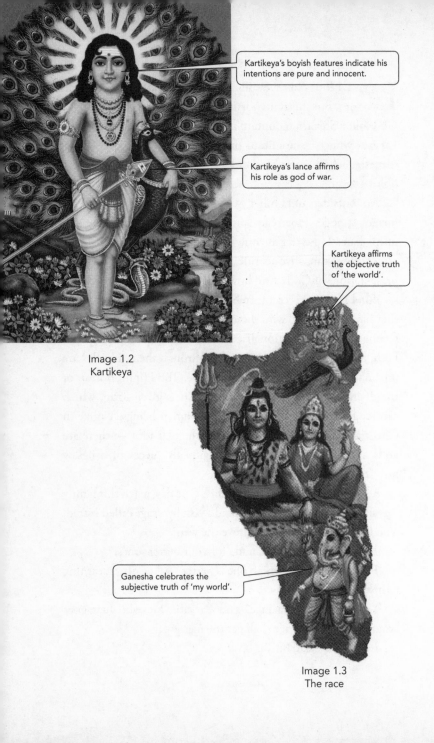

Kartikeya's boyish features indicate his intentions are pure and innocent.

Kartikeya's lance affirms his role as god of war.

Image 1.2
Kartikeya

Kartikeya affirms the objective truth of 'the world'.

Ganesha celebrates the subjective truth of 'my world'.

Image 1.3
The race

Kartikeya, shown in Image 1.2, immediately mounted his peacock and rose to the sky, determined to be the first to go around the world thrice. Ganesha, however, did not move. He continued to sit beside his parents, playing with his rat. Kartikeya went around the world once, then twice, wondering what Ganesha was up to. Ganesha still showed no signs of moving. As Kartikeya was about to complete his third and final round, Ganesha got up, and, as shown in Image 1.3, quickly ran around his parents thrice and declared, 'I have won!'

'What do you mean, you won?' asked Kartikeya. 'It was I who went around the world thrice. You just went around our parents.'

'That's not true. You went around the world. I went around my world. Tell me, which world matters more?'

The world is objective; my world is subjective. The world is rational and scientific; my world is intuitive and emotional. The world is global; my world is local. Both are truths but, as Ganesha asks, what matters more?

Every culture views the world through different lenses. For some, there is one formless divine; for others, the divine has many forms. Who is right? For some, there is only one life with no rebirth; for others, this is just one of many lives. Who is right? Answers to these questions are never universal. They are cultural. They spawn beliefs. From beliefs comes behaviour that can make us either less tolerant or more accommodating. That is why my world does matter.

Myth is an idea churned in my world; mythology is the set of stories, symbols and rituals that communicate a myth. Like the idea, the stories, symbols and rituals may seem absurd to the outsider, but will make perfect sense to the believer. Image 1.1

Image 1.4
Different forms of the divine

is an example of this, as are the other images in this book. Each one makes sense to Hindus both in form and in content. They do not attempt to make sense to those who are not Hindus. They speak a language that is indifferent to rationality. And so, rivers spout from Shiva's topknot and his son has an elephant head. A subject such as this must, therefore, be approached with empathy and a genuine spirit of curiosity, realising that these are windows to a culture's soul.

Empathy is sorely lacking in modern times. Everything is judged. Everything is measured. All thoughts are expected to be legitimised through fact and evidence and mathematics and science. But many things in life cannot be explained with logic, least of all life, death and God. What happens after death? Who knows? Different cultures have different answers. Each is a subjective truth. Each is, therefore, a myth, a story, a belief.

Shiva is a God; he is not God. Notice the difference in grammar: a God, not God. The emphasis on the singular means there are other Gods. This is the first thing that is unique about the Hindu world — God is not a singular entity. God is not a masculine entity either. As shown in Image 1.4, Parvati, Shiva's wife, is a Goddess, equal in stature to her husband. Ganesha and Kartikeya are gods, spelt without capital, indicating their lesser status relative to Shiva and Parvati. Ganesha removes obstacles and Kartikeya leads other gods in battles against demons, but when Shiva shuts his eyes, the whole world ceases to be, which is why Shiva is called the destroyer, and is considered God. Parvati is a Goddess because she embodies the whole range of emotions from fear to love, from domination to affection, while Ganga, the river who spouts out from Shiva's topknot, is a goddess, her divinity restricted to the river she embodies.

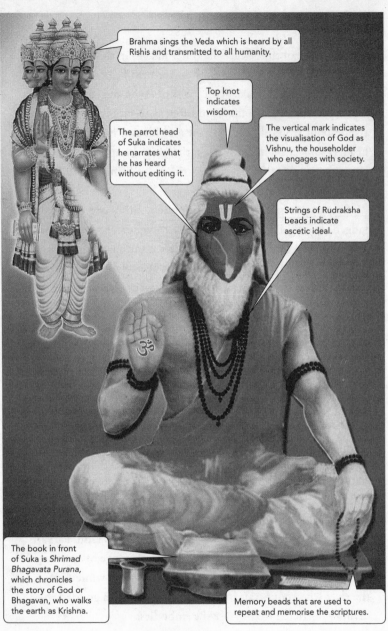

Image 1.5
Brahma blessing Suka

The idea is this — divinity is formless, but, being human, we require forms to comprehend it. Every form, by its very nature, is incomplete: no single form is capable of encompassing totality. Through several incomplete forms of Gods, Goddesses, gods and goddesses, however, we at least have a sense of what the entire notion of the divine is.

Things are not so simple. In a temple where Ganesha is worshipped exclusively or Kartikeya is alone, without his father or mother, the gods become God — finite manifestations of the infinite divine.

Through forms, all cultures have expressed their own realities. Image 1.5 is a case in point. It shows a four-headed man holding a book and blessing a parrot-headed sage. The four-headed man is Brahma, the first being who sang the Veda and transmitted it through sages known as Rishis to humankind. The Veda is a set of hymns which serves as the wellspring of Hindu wisdom. These hymns are said to be timeless and universal and of non-human origin, and hence divine revelations. It is said that the Rishis forgot the hymns during a great drought. Luckily they were re-compiled by a sage who came to be known as Vyas, or the compiler. The parrot-headed sage is Suka, the son of Vyas. Through him, all Vedic wisdom has come down to us.

There are symbolic communications in this image of a four-headed man blessing a man with the head of a parrot. Brahma is male — his form excludes the female form. Thus he is incomplete. His existence implies the existence of the female. But where is she? She is the invisible idea that validates and completes this image. She is the formless knowledge that is being transmitted from Brahma to Suka. She is called Saraswati, a Goddess sometimes addressed as Veda-mata,

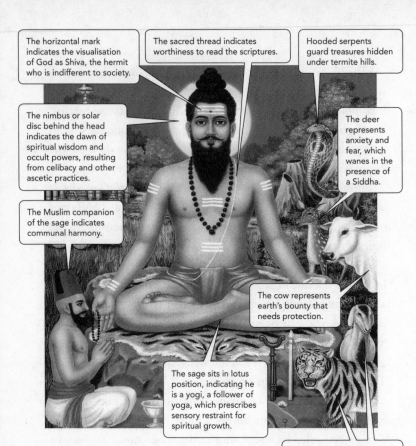

The horizontal mark indicates the visualisation of God as Shiva, the hermit who is indifferent to society.

The sacred thread indicates worthiness to read the scriptures.

Hooded serpents guard treasures hidden under termite hills.

The nimbus or solar disc behind the head indicates the dawn of spiritual wisdom and occult powers, resulting from celibacy and other ascetic practices.

The deer represents anxiety and fear, which wanes in the presence of a Siddha.

The Muslim companion of the sage indicates communal harmony.

The cow represents earth's bounty that needs protection.

The sage sits in lotus position, indicating he is a yogi, a follower of yoga, which prescribes sensory restraint for spiritual growth.

The goat and tiger standing together indicates the subversion of the jungle law so that the prey no longer fears the predator.

Image 1.6
A holy man or Siddha

mother of the Vedas. Brahma did not compose the Vedas —
no man can create anything without woman, not even God.
Some say she inspired him; some say he heard her. Either way,
the Veda came into being. Brahma merely communicates it.

The four heads represent four expressions of the Veda.
They represent the four goals of life, each one validated by
Vedic wisdom: dharma (righteous conduct), artha (economic
activity), kama (pleasurable pursuits) and moksha (spiritual
practices). Just as Brahma is incomplete without any of these
four heads, life is incomplete without any of these four goals.

Suka means parrot; the parrot-head of Suka indicates that
the transmission is parroted, hence flawless, without editing and
interpolation. Thus the mythological image communicates the
belief of a people regarding the source of their divine revelations
and the transmission of that knowledge.

Image 1.6 shows a Hindu holy man, a hermit who has
achieved full control over his mind and his senses. He has no
desire to dominate the world. He has transcended all human
limitations. When this happens, strange things follow: all
conflicts cease. There is no tension with other religions. Goats
and cows do not fear tigers. Serpents, known as guardians of
treasures in folklore, share their wealth freely. In other words,
the negative side of nature and culture is subverted. There is
peace and harmony; fear and deprivation are absent. This is
heaven, a perfect world. For Hindus, such a man who transforms
earth into paradise is worthy of worship, not just as a saint but
sometimes as an earthly manifestation of God.

Image 1.7 is a local manifestation of God. He is called
Khandoba and is much revered in the state of Maharashtra. He
rides a horse, and the woman with him is his first wife, Mhalsa,

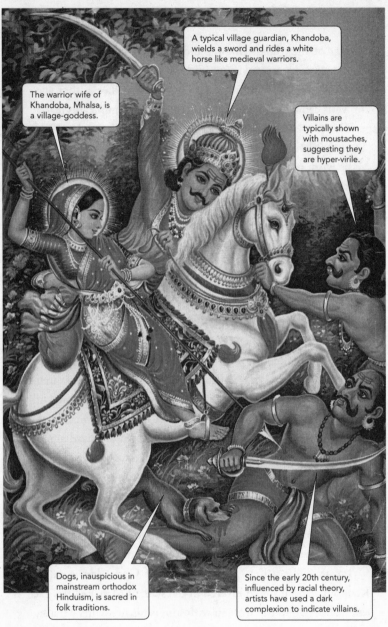

Image 1.7
Khandoba

daughter of a merchant. The two demons they are fighting are Mani and Malla. Sanskrit texts refer to Khandoba as Martand Bhairava, a fierce form of Shiva, local to the Deccan region. He is a kshetrapala, a guardian of land. As a protector, he fights demons. Some demons, like Mani, who ask for repentance, become deities in their own right within the temple precinct, while others, like Malla, whose image is embedded on the steps leading to the shrine, continue to be punished by being trampled on by devotees who come to pay their respects to Khandoba.

Khandoba loves turmeric: his shrine, his devotees and his images are covered with turmeric. Turmeric is a golden herb associated with antiseptic properties, and through his intimate association with it, Khandoba's role as protector is reinforced. Its bright yellow colour suggests gold and so, through turmeric, Khandoba's role as provider is also acknowledged. He is a virile god whose grace grants children. He has many wives — the first of whom, Mhalsa, belongs to the merchant community. The second, Banai, belongs to the goatherd community. There are other wives, one belonging to the tailor community, another to the community that presses seeds for oil, and one belonging to the gardener community.

The tale of his many marriages binds various communities ritually through a single village-god. Thus each community retains its own identity while being united through Khandoba. Together, they support each other in the struggle to survive. By linking Khandoba, a local village deity, to a pan-Hindu God like Shiva, the village becomes part of a larger Hindu community. The village is unique, yet part of a greater whole. Its local god is a local manifestation of a more cosmic God.

Thus the mythology of Khandoba communicates the belief

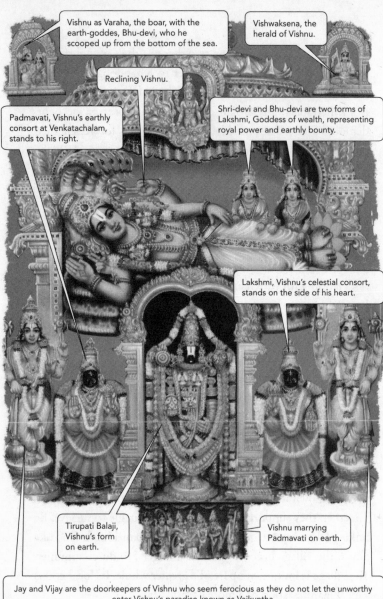

Image 1.8
Tirupati-Balaji, God on earth, with his wives and doorkeepers,
as visualised in Andhra Pradesh

of the believers. They want a god who satisfies their local needs, provides for them and protects them. They also want to retain their local family and village identity while being part of a more global Hindu identity. Thus they have a deity who is both god and God.

Image 1.8 introduces us to another pan-Hindu God, Vishnu, who is quite unlike Shiva. While Shiva is a mendicant who lives atop a snow-clad mountain, Vishnu is a king who reclines on the coils of a serpent that floats on the ocean of milk. At his feet are his two wives, Shri and Bhu, Goddesses of wealth and earth. The lower half of the image is a local manifestation of Vishnu. It is Tirupati Balaji whose shrine is located in the state of Andhra Pradesh.

The story goes that Vishnu left his abode and came to earth searching for his wife, Shri, who had walked away after a quarrel. While searching for her, he fell in love with a princess called Padmavati whose father ruled a kingdom located in the shadow of seven hills. Like Khandoba, who wooed his many earthly wives, Vishnu decided to woo Padmavati. After many romantic adventures, she agreed to marry him, but asked for a huge bridal price. To pay the price, Vishnu took a huge loan from Kubera, the treasurer of the Goddess Shri. So long as Vishnu is in debt, he cannot return to his heavenly abode with either Padmavati or Shri. So he stays atop the seven hills in the form of Tirupati Balaji. To help him repay his debt, devotees offer him great wealth; in gratitude Vishnu grants them blessings of prosperity and abundance.

The goddesses in Image 1.9 hail from Gujarat. Known as Chamunda and Chotila, their red and green saris, their tridents, their lion, and their location atop a hill indicate that they are

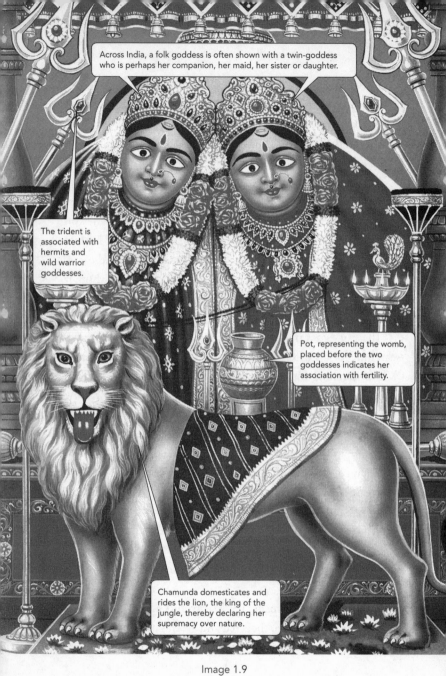

Image 1.9
Chamunda and Chotila

local forms of the pan-Hindu Goddess, Shakti, also known as Parvati, the princess of the mountains, who married Shiva, the mountain mendicant. Thus they are goddesses and Goddesses, much like the god/God in Images 1.7 and 1.8. Though known only locally, through them devotees become part of the larger Hindu community. No one is sure why the goddesses appear as twins in the image. Some say that Chotila is Chamunda's sister; others say she is her companion. The two goddesses perhaps represent the two forms taken by the Goddess to kill the two demons Chanda and Munda, after whom the goddesses came to be known as Chandi and Cha-mundi. Maybe Chamunda (she who killed Chanda and Munda) is the Goddess and Chotila (the one who resides on the peak) is the local goddess. Unlike in Images 1.7 and 1.8, Chandi and Cha-mundi have no male attendant or consort because marriage is supposed to domesticate. These two goddesses are warriors, and their martial potency is retained by not allowing themselves to be diverted by matrimony or maternity.

Taking their cue from the transformation that is happening to the hermit depicted in Image 1.6, many scholars are of the opinion that village-gods, like Khandoba for example, were local heroes deified by legend. Perhaps Balaji was actually a wise stranger who married a local woman and transformed the community around the seven hills. Maybe the two goddesses were two ordinary women, sisters or companions, who earned the admiration of the villages with their martial skills. Such conclusions are attempts to rationalise a religious practice, and rarely have an impact on the faith.

Image 1.10 is certainly of a historical figure who was transformed by people into a goddess. She was the 12th-century

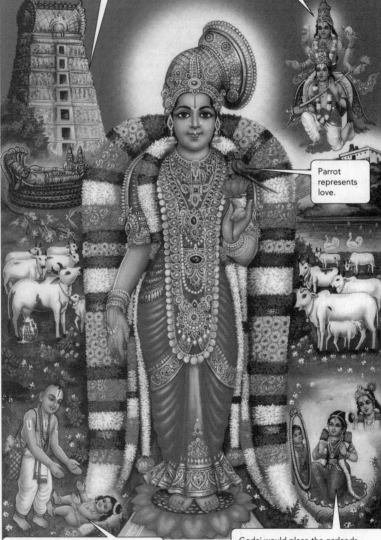

Image 1.10
Andal, the poet-saint

Tamil poet-saint Andal, also known as Godai, 'the one given by cows', so named because she was found as a baby amidst grazing cows and was raised by a childless temple priest. Andal grew up and fell in love with the presiding deity of her father's temple. She would put the flowers meant for the deity around her neck and then give them to the deity. This angered the priests who thought her touch defiled the sacred offerings. But then the deity appeared in the dreams of the priests and informed them that he liked the offerings more because they had been touched by one who loved him truly. Andal eventually came to be known as the consort of the temple deity, and over time came to be regarded as a goddess. In her image she has only two hands, indicating she is human, and she holds a parrot and a lotus indicating that she is associated with the principles of love — for both the parrot and the lotus are associated with Kama, the Hindu Cupid.

Belief in the notion of humans marrying gods and goddesses no doubt led to the medieval practice of devadasis, or brides of the Gods, who lived single lives in temples, singing, dancing and even providing sexual pleasure to priests and pilgrims. While it was largely women who were married to temple deities, men were also similarly dedicated in some parts of India. In the shrine of Khandoba existed vaghyas and muralis, boys and girls dedicated to the deity, who were not allowed to marry and were expected to earn a living by singing and dancing. These practices that were open to all forms of exploitation have since been struck down as illegal by the modern Indian state.

Not all deities are associated with a particular geography. Image 1.11 of Vishwakarma is associated with the community of artisans. He is worshipped by people who use tools. Vishwakarma is an ancient god, the Vedic Vulcan. In Vedic

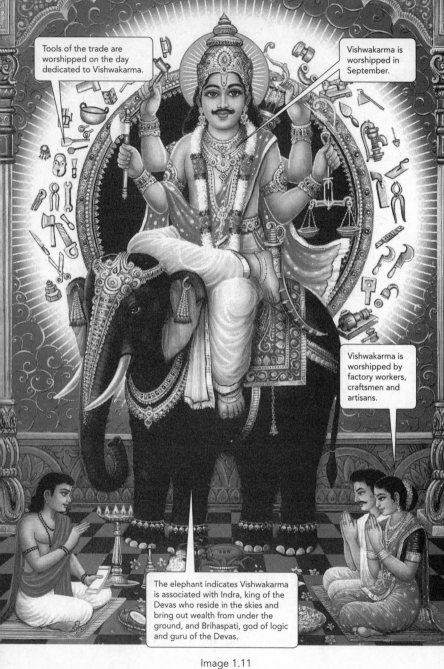

Image 1.11
Vishwakarma

times, he was known as Tvastr and was god to potters, metal smiths, carpenters and weavers. Vishwakarma rides an elephant and this equates him with Indra, the king of the gods, the Vedic Zeus.

Similarities between Kama and Cupid, Vishwakarma and Vulcan and Indra and Zeus do lead many to hastily conclude that Hindu mythology is similar to Greek mythology. But Greek mythology is quite different from Hindu mythology; it reflects the subjective truth of the Greeks, which was radically different from the subjective truths of the Hindus. The Greeks did not believe in God — they had gods and goddesses, but no God or Goddess. The gods of Greek mythology became masters of the universe by overthrowing the Titans, an earlier race of powerful beings, who in turn had become powerful by overcoming Giants. Such a theme of repeat succession is missing in Vedic literature. Unlike Greek gods, the Devas (Hindu gods) never feared the Manavas (humans) would overthrow them. Devas did have enemies known as Asuras, but these were not Titans; both the Devas and the Asuras were children of Brahma and their fight was an eternal cyclical one with alternating victories and defeats, believed to represent the alternating cycles of sowing and harvesting.

Not much is known about Vishwakarma. Some identify him with Brahma himself. He is said to have given shape to the world. It is he who fashions the child in a mother's womb. He made the weapons of the gods. He designed the city of Amravati, the abode of the Devas located above the sky, which humans consider Swarga or paradise. He transforms the knowledge embodied in Saraswati and transmitted by Brahma into tools that help man survive and thrive.

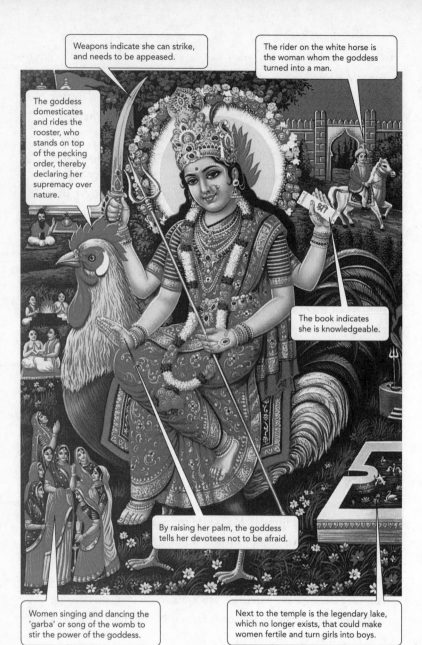

Image 1.12
Bahuchara

While the god in Image 1.11 is revered by artisans, the goddess in Image 1.12 is much revered by a community that is marginalised by mainstream society. This is Bahuchara. No one knows what her name actually means. Some say it is derived from Bahu-achara, many-behaviours, perhaps acknowledging the tolerance of the goddess, for her devotees not only include men and women from local communities in Gujarat who desire children, but also Hijras from many parts of India, who seek gender fulfilment. Hijras are men who feel they are women and so do not live in mainstream society. They dress as women and live with other Hijras in the fringes of society, begging or even prostituting themselves to earn a living. Some Hijras castrate themselves and while doing so pray to Bahuchara, the goddess who once turned a woman into a man, allowing her to be a husband to the woman who had been given to her as a bride.

According to the story told by devotees of this local goddess, two friends met in a fair after many years. Both their wives were pregnant and a holy man informed them that one would be the father of a son and the other would be the father of a daughter. To seal their friendship, the friends decided to get their unborn children married. To the horror of the parents, the 'son' turned out to be a daughter. The truth was kept hidden as the holy man promised them that what was foretold would certainly come to pass. The girl was brought up as a boy and in due course was asked to go and fetch his bride. With trepidation, she travelled on a mare to the village of the bride. On the way, both fell into a pond. When they emerged she had become a man and the mare had become a horse. A bitch who was following them and had also fallen into the river turned into a dog. This all happened because Bahuchara was next to the pond. From that day, people

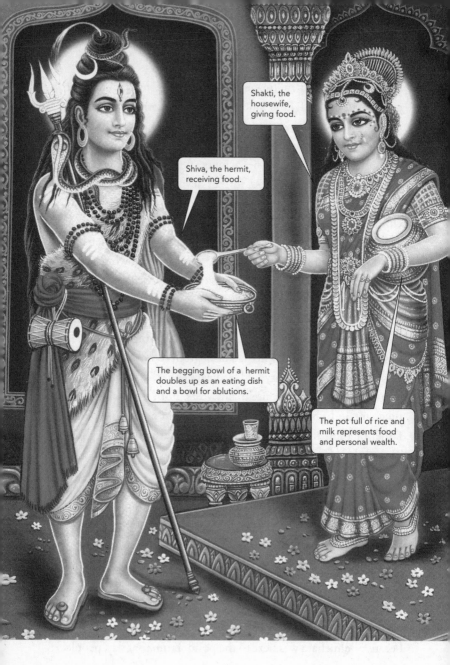

Image 1.13
Feeding Shiva

seeking sons have thronged to her shrine. Hijras come because they believe that, by serving the goddess, they will be born as complete men or women in their next life.

Other stories of this goddess tell us that she was a young girl who turned a thief into a Hijra when he dared to molest her while she was on her way to her wedding. Others say that she was a bride who was horrified to discover that her husband was not a man but a Hijra, and so turned into a goddess offering salvation to all Hijras if they served her instead of marrying women. Thus, through this goddess, even the most marginalised minority is included by the divine.

Image 1.13 belongs to no particular geography or community. She is the universal and timeless kitchen-goddess, Annapurna, the mother who feeds. Without her, there is starvation, a universal fear: this makes Annapurna a universal goddess. But food alone is not enough to live a full life. One needs spiritual meaning. Image 1.13 depicts this, while Image 1.14 shows Annapurna as an enshrined deity. Her most popular shrine is located in Kashi, on the banks of the river Ganga.

In Vedic times, 4,000 years ago by the most conservative estimates, seers composed a hymn called the Gayatri, saluting the divine, seeking the light of knowledge to pierce the darkness of ignorance so that the intellect is roused and all that one desires, materially or spiritually, is realised. At the time this hymn was composed, Hindus did not have temples. People worshipped the divine through chants and by making offerings to fire and water. However, chanting the hymn and contemplating on it was only possible for those with superior concentration powers. For most people, a more emotive approach to the idea was required, and so the hymn came to be visualised as a goddess,

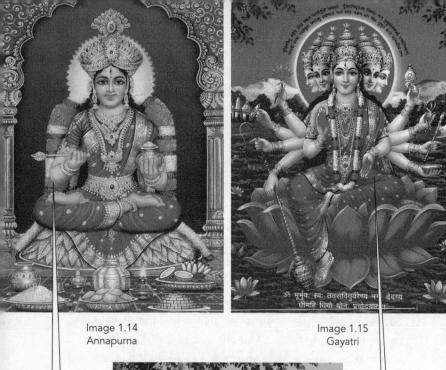

Image 1.14
Annapurna

Image 1.15
Gayatri

The goddess who feeds becomes the Goddess of wealth.

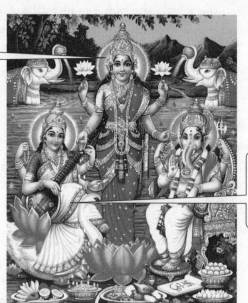

The goddess of a Vedic hymn becomes the Goddess of knowledge.

Image 1.16
Lakshmi, Saraswati, and Ganesha

Image 1.15. Through the adoration of this goddess, one hoped to get the same outcome as by chanting the hymn. Thus the idea of the Gayatri hymn came to be embodied within the image of a goddess called Gayatri. If Image 1.14 represents the yearning for basic physical fulfilment of man, then Image 1.15 represents the yearning for his spiritual fulfilment.

Annapurna, the goddess, becomes Lakshmi, the Goddess of wealth, dressed in red, standing on a lotus, flanked by white elephants and showering gold in Image 1.16. Likewise, Gayatri the goddess, becomes Saraswati the Goddess of knowledge, dressed in white, with a lute, a book and memory beads in her hand. She is the knowledge that was first heard by Brahma, in Image 1.5, causing him to sing the Veda. To Lakshmi's left is Ganesha, the son of Shiva, who removes obstacles and brings luck.

Ganesha is one of the most popular gods of Hinduism in recent times. He is worshipped before one starts any project. He is supposed to remove all obstacles, all unforeseen hurdles. His elephant head, viewed symbolically, makes a lot of sense. The elephant head indicates power. The elephant is a strong animal with no natural enemy in the forest. No animal dares to cross an elephant's path, making it a creature that is unstoppable. The fat body with a potbelly implies availability of excess food and the possibility of less work, suggesting affluence and prosperity. The rat is one of the most annoying pests in the world. It can slip through any crack, bite its way through any obstacle and steal grain. As Ganesha's pet, the rat symbolises the problems of life tamed and controlled by Ganesha. Thus, Ganesha represents a life full of power and prosperity without any problems. The form of Ganesha is a container of an idea. Ganesha is worshipped

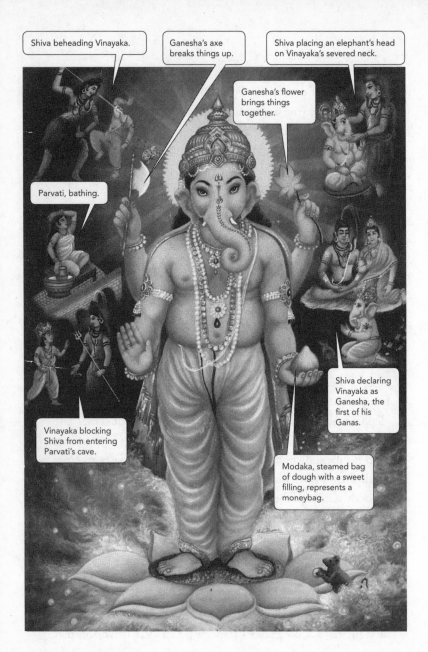

Image 1.17
Ganesha

because the idea that he evokes is something that Hindus aspire for.

The idea of Ganesha is reinforced by the story of his birth. His story is told in Image 1.17. Parvati married Shiva even though Shiva was a hermit, uninterested in worldly life. Shiva did not want to be a father — he saw no point in raising a family. But Parvati longed to be a mother. While bathing, Parvati scrubbed the turmeric paste she had anointed her body with and moulded it into a doll, into which she breathed life. The child thus created was named Vinayaka, one who is born without (vina) the help of man (nayaka). Shiva did not recognise Vinayaka as the son of his wife and Vinayaka did not recognise Shiva as his mother's husband. When Vinayaka once prevented Shiva from entering his own house, on his mother's directions, an angry Shiva beheaded Vinayaka. Parvati was inconsolable in her grief until Shiva resurrected the child by replacing his head with that of an elephant. This was no ordinary elephant; it was Airavat, the elephant of the rain-god Indra, and it was found in the north, the direction associated with immortality, stillness and permanence.

Ganesha thus represents the union of two opposites — Shiva who does not want to marry and raise a family, and his wife who does. Shiva represents spiritual aspiration, the desire to focus on the soul within. Parvati represents material aspiration, the desire to focus on the family and the world around. Hindus have always sensed a tension between these two goals. Ganesha represents a balance between the two. Image 1.18 reinforces this cultural conflict when it shows the hermit, Shiva, as a father, holding his son, Ganesha, on his lap.

Ganesha also represents a balance between a mortal body and an immortal head. His human body, created by his mother

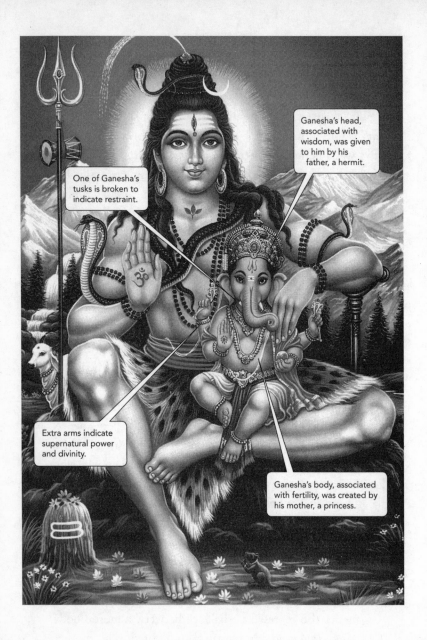

Image 1.18
Shiva with his son

on earth, represents the material world which is impermanent, going through cycles of death and rebirth. His elephant head, secured by his father from the gods, represents the spiritual world, which is permanent.

So this one image of Ganesha can serve as a medium to lofty metaphysical ideas to the Hindu and at the same time function at a very basic level — providing luck as one goes about facing the daily tribulations of life.

Thus, we find a whole host of images presenting the subjective truth of the Hindus. There are gods, goddesses, Gods and Goddesses trying to convey that the divine is both abstract and concrete, both local and global, embodying not only spirit but also matter. Together, they attempt to capture the totality of the infinite divine. Together, they serve as windows to the Hindu worldview.

2
NARAYAN'S SECRET
What dies is always reborn

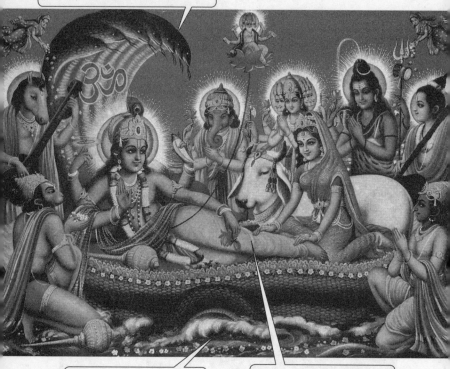

Image 2.1
Reawakening of Narayan

Image 2.1 shows Narayan waking up. It is the moment the world comes into being. Just as our world does not exist when we sleep, the whole universe does not exist when God is in deep slumber. Narayan is God. His deep slumber marks the dissolution of the world. Before he slept, he must have been awake and the world must have existed then. Thus Image 2.1 marks the rebirth of a world that exists and ceases to exist cyclically, with Narayan's waking and sleeping states.

The Greeks did not believe in rebirth. Neither do Christians and Muslims. There is only one life and hence the sense of urgency for the Greeks to be heroes, for the Christians to be saved by God and for the Muslims to surrender to God. It's an urgency that does not exist for Hindus. This life is one of the many lives we are supposed to live. This world is one of the many worlds that have come and gone.

Narayan sleeps on an ocean of milk. This ocean has no shore. It is made of milk, but the milk is still, without ripples or waves. All things will emerge from it when Narayan awakes, just as butter can be drawn out when milk is churned. The ocean of milk thus represents possibility. When Narayan is asleep, the world entropies; there is no form, no identity — just a homogenous mass of matter, waiting to be churned.

The serpent on whom Narayan is sleeping is called Sesha, the remainder, that which remains when all else is destroyed. Some say that makes him a representation of time. No one is sure, for when one is in deep slumber, how does one know what is left behind? Time moves. But Sesha is hooded and coiled, indicating he is static. Narayan sleeps on the coils of Sesha; in other words when Narayan sleeps, time is still. One is not clear what happened first — the stilling of Sesha or the sleeping of

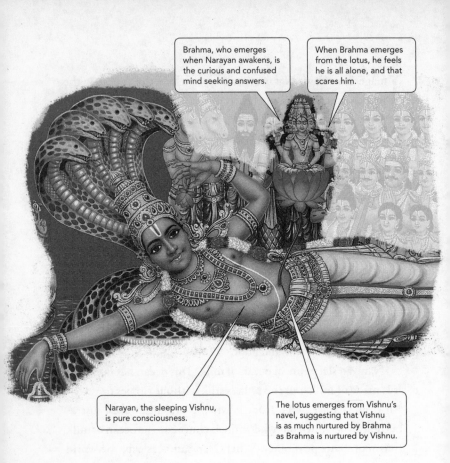

Image 2.2
The rebirth of Brahma

Narayan — or if they both occurred together?

Sesha is either called Adi Sesha, the primal remainder, or Ananta Sesha, the endless remainder. The name draws attention to the fact that while Narayan is asleep, the world still exists around him. But no one is aware of it; hence, for all practical purposes, it does not exist. According to Vedanta, without the observer, there is no observation. Narayan is the observer. When he is asleep, he observes nothing. He is in deep slumber. He does not dream. He has no sense of either the real world or the dream world. Without the observer observing, the observation cannot exist. Hence, no world exists when Narayan is asleep. This is the end of the world.

The best way to understand this idea is to ask ourselves: does our world exist when we are in deep slumber? Yes, it does. But do we experience it? No, we don't. Thus, the world exists but not my world. Without us, our world does not exist. Without the observer, there is no observation.

Image 2.2 shows the awakening, or the re-awakening, of Narayan. This is creation. The artist is visualising this as the moment when we wake up — become conscious — but have not gotten up from the bed. When Narayan's eyes open, his senses become sensitive to the world around. Inputs rush in from the eyes, the nose, the ears, the tongue and the skin. What is sensed is identified and classified and even judged based on memories. Consciousness, which was like an uncreased piece of paper, has now started to crumple. The world ceases to be pure: it has colour and shape and value, some things we like, some things we don't. This crumpled consciousness, not as pure as Narayan, is visualised as Brahma, seated on a lotus that has sprouted out of Narayan's navel.

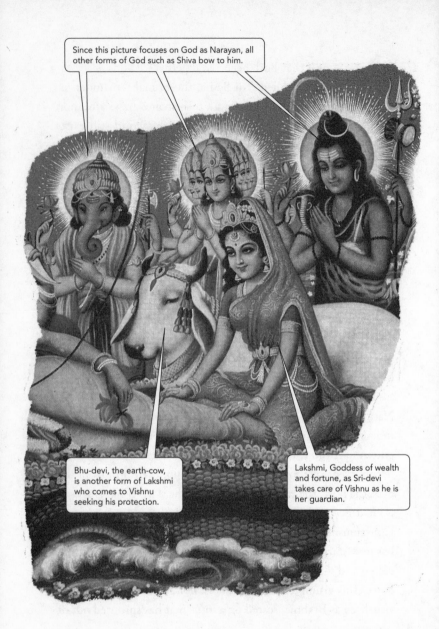

Image 2.3
Sri-devi, Bhu-devi and Shiva's family

Rising from the navel, with a lotus stalk for an umbilical cord, Brahma's lotus is like a placenta that nourishes an unborn child in the mother's womb. So one wonders: who is the creator? Did Narayan create Brahma, or is Brahma the womb that nourishes Narayan? Does the observation create the observer? Or is it the observer who creates the observation? Are we constructs of the world around us or is the world constructed by us? Chapter 7 discusses Brahma in more detail.

Narayan's awakening is a moment of celebration. It marks the creation of the world just as our world comes into being when we awaken and become aware of our world. Angels, visualised as flying women, shower flowers. From an academic point of view, it is interesting to keep in mind that the notion of flying heraldic angels came to India only after exposure to European culture in the 16th century.

At Narayan's feet in Image 2.1 is his consort, Lakshmi, the Goddess of wealth, shown in more detail in Image 2.3. She nourishes mankind. She is also portrayed as a cow. She is Go-mata, the cosmic cow who contains the whole world within her. Narayan is her cowherd. Hence, when awake, Narayan is called Gopala, the keeper of the cow. The cow is the world and whenever the world is in trouble Narayan rushes to her rescue. Narayan awake is called Vishnu, the guardian, the protector, the preserver.

Also seen in this picture is Shiva, the hermit who destroys the world by shutting his eyes to it. But Shiva here is not a destroyer. His eyes are open. And with him are his two sons, the six-headed Kartikeya and the elephant-headed Ganesha, representing physical and intellectual capability respectively. Thus, the waking of Narayan and the resulting creation of the

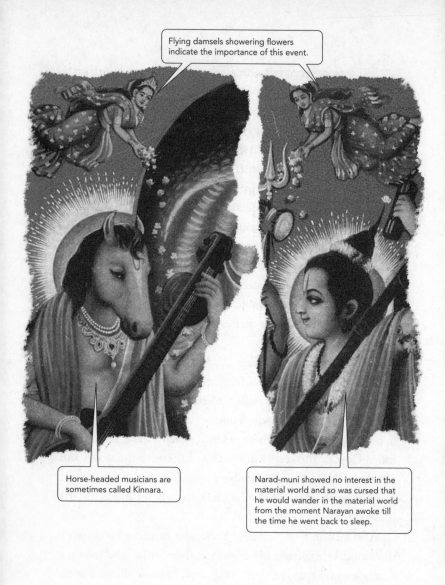

Image 2.4
Celestial musicians

world are associated with Shiva, the indifferent hermit opening his eyes, marrying and producing children to become Shankara, the attentive householder. This is expounded on in Chapter 4.

In Image 2.1, there are two men holding lutes on either side of Narayan, shown in greater detail in Image 2.4. The one at his feet is Narad and the other, with the head of a horse, is Tumburu. The two men are rival musicians. Narad is a Rishi, or sage, while Tumburu is a Kinnara or a celestial musician. They often vie to marry the same girl in several mythological stories, and turn to Vishnu for help. Vishnu does help, but in such a way that the girl — always an avatar of Lakshmi — ends up marrying him. Narad and Tumburu yearn for the earth-goddess but do not get her. They want to possess her like a prize, and are unworthy suitors; Vishnu loves, adores and protects her and is, thus, a worthy suitor.

Narad was created from the mind of Brahma. On his birth, he had no interest in the world and encouraged all creatures not to marry or reproduce. The world, thus, did not grow. This angered Brahma, who cursed Narad that he would move around the world restlessly and live till it was time for Vishnu to sleep once more. A restless Narad, therefore, is the cause of many troubles (as the story in Chapter 1 informs us). He enjoys provoking people. He constantly compares people and thus spreads anger and ignites quarrels. He fills the mind with jealousy and insecurity.

Crouching on either side of Narayan are the monkey Hanuman at his head and the hawk Garuda at his foot, shown in greater detail in Image 2.5. Whenever possessiveness, restlessness, insecurity and jealousy threaten the world, Vishnu goes about setting things right. Garuda serves as his mount and

Image 2.5
Guardian gods

carries him to the troubled spot.

Hawks and serpents are natural enemies. In the presence of a hawk, a serpent cannot afford to be still. It uncoils itself and starts to slither and slip away. Thus Garuda provokes the world to move. Vishnu's association with both serpent and hawk, the still Sesha and the flying Garuda, represents consciousness in both sleeping and waking states.

Sometimes Vishnu transforms into a human to set things right. In one of his avatars, he was Ram, lord of Ayodhya (more about him in Chapter 6), and it was at this point that Hanuman became his companion, helping him regain his lost queen, Sita. Hanuman is called sankat-mochan, the trouble-shooter. His presence implies that when the world awakens, troubles also begin, but it is possible for the mind that creates the problem to come up with the solution as well.

When Narayan awakens to become Vishnu, the mind starts organising the world (Brahma) using definitions, classifications and judgements. Withdrawal (Shiva) gives way to participation using one's physical capability (Kartikeya) and intellectual capacity (Ganesha). There is the desire to enjoy and possess the world (Tumburu). There are also negative emotions like restlessness and envy (Narada). But all these problems can be solved by the mind when it is willing to fly like Garuda and be disciplined like Hanuman.

Thus Image 2.1 is rich in symbols and attempts to capture creation. Hindu scriptures repeatedly refer to creation as the result of awareness. Things are born when we become aware of them. Thus creation is not an objective construction — it is a subjective realisation. Things are created every second and, with each creation, something is destroyed. Creation is like a wave.

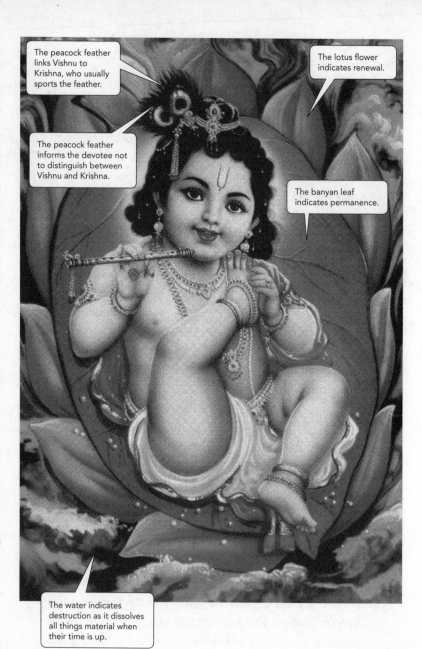

Image 2.6
Baby on a banyan leaf

Hence destruction is visualised as a stormy ocean where ideas collapse and dissolve as new things struggle to churn their way out.

Image 2.6 shows a newborn child on a banyan leaf. Once, a sage called Markandeya was granted a glimpse of Pralaya, the end of the world. This vision was marked by heavy rains and waves rising to consume the earth, until everything was submerged. Water, especially the sea, represents formlessness. It is the symbol of entropy, dissolution. How does one visualise nothingness in art? Which form represents formlessness? One does it by showing the sea. A stormy sea shows the process of destruction while a still sea shows the moment before rebirth.

The sight of the dying world filled Markandeya with dread and despair. It was then that he heard a gurgling happy sound. He turned around and found a baby lying on a banyan leaf, cradled by the waves of destruction. A baby is the symbol of rebirth or renewal of life. Markandeya saw the baby and realised that what one considers the end is actually just a phase, a part of the process; after the end comes the beginning. This is fundamentally different from the Greek and Biblical worldview, where death is a full-stop. In the Hindu world-view, death is a comma; there is no full-stop.

That the baby is lying on the leaf of a banyan tree is significant. The banyan tree is believed to be immortal; it represents that which cannot be destroyed. What cannot be destroyed even when all forms dissolve to become formless? It is the soul. Thus the baby is cradled by the soul. Markandeya is being told that the indestructible soul is witnessing the end of the world dispassionately. It may seem cruel and uncaring as it whips up the malignant storm, but when the waters calm, the

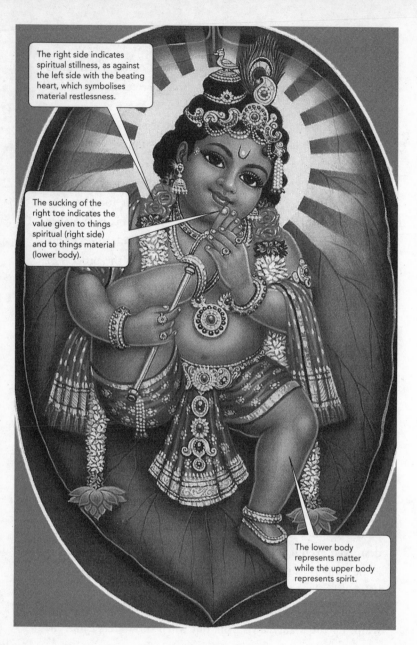

Image 2.7
Baby Narayan sucking his right toe

soul will rest and re-emerge in innocence like a gurgling baby.

The banyan leaf lies within a lotus. The flower is the lotus of Brahma, that which blooms when Narayan awakens. Thus, the image simultaneously captures death (water) and rebirth (leaf and flower).

The baby in Image 2.7 holds a flute in his right hand and his right big toe with his left hand. The right side in Indian art represents the soul and intellect because the left side, with the beating heart, represents movement, hence matter and emotions. By holding the right toe with the left hand, God is connecting the spiritual with the material, the intellectual with the emotional, all the while making music with the flute, indicating a playful approach to life. The world exists to be enjoyed and explored by the soul in the spirit of play. The infant form of God conveys both innocence and the idea of material renewal.

In Hindu belief, the soul is permanent and ever present. But it is beyond form; how then does one represent it in art? One has no choice but to take recourse to form. Any form will be imperfect and incomplete. Typically, the soul is visualised as male, and in Images 2.6 and 2.7, as a baby. Both these forms are inherently flawed. However, we have no choice but to use imperfect forms to communicate a perfect truth.

Image 2.8 is based on a story that draws attention to the nature of the soul. The story comes from the Vishnu Purana, the lore of Vishnu, and speaks of a conflict between father and son. The father, whose name is Hiranakashipu, believes he is immortal because he has secured a boon that prevents him from being killed by any human or any animal, any god or any demon, by a weapon or a tool, inside any dwelling or outside,

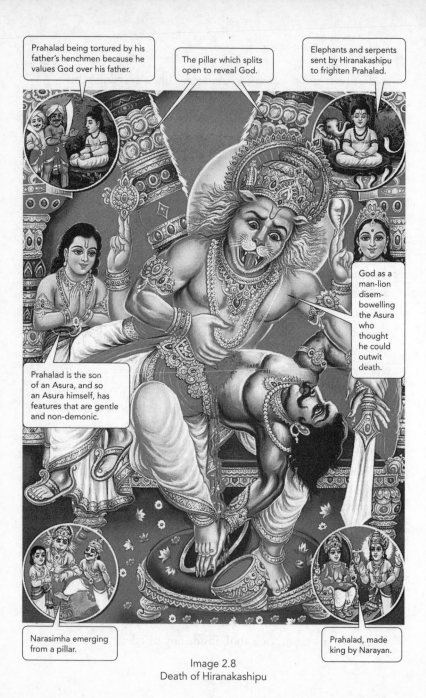

Image 2.8
Death of Hiranakashipu

above the ground or under it, during the day or the night. Since he considers himself immortal, Hiranakashipu is convinced he is a God, worthy of worship. But his son, Prahalad, believes his father is mortal; he insists that he will only worship Narayan, the formless, timeless, omnipresent God.

'Where is this Narayan present?' asks the father.

'Everywhere,' says the son, 'even in the pillars of your palace.'

To prove his son wrong once and for all, Hiranakashipu breaks down a palace pillar. We can see it in the background — a vertically split pillar.

From this pillar emerges a fantastic creature called Narasimha, part lion and part human. This creature crosses the boundary between the animal and the human world. It emerges from the realm of impossibility, breaking all boundaries, challenging our notions of what is normal and what is not. Narasimha is God, he is a form of Narayan. One is being told that what is impossible for the human mind to conceive exists in the mind of God. Hiranakashipu is blinded by power and assumes he knows the ends of the world. But God makes the impossible possible. God appears as a creature that Hiranakashipu believes is unnatural, hence nonexistent. Narasimha is supposed to be a god but evokes fear like a monster, hence seems demonic. He is neither god nor demon, or both, maybe, for father and son.

This creature, neither man nor animal, or perhaps one who is both, drags Hiranakashipu to the threshold of the palace — neither inside a dwelling nor outside. There, at twilight, which is neither day nor night, he places Hiranakashipu on his lap, which is neither under the ground nor on the ground nor above the ground, and tears him apart with his fangs, which are neither weapons nor tools. Thus Hiranakashipu, who thought he was

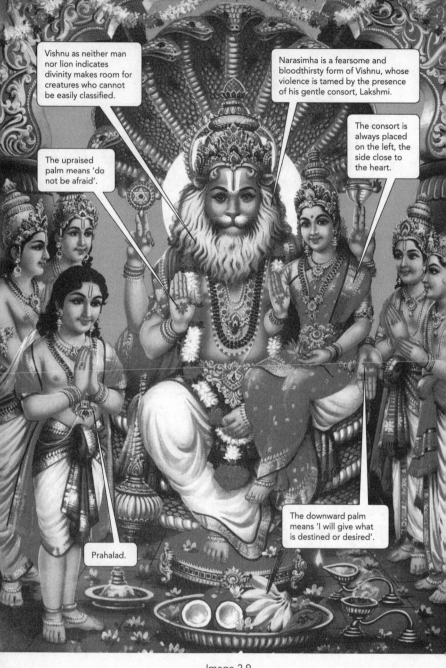

Image 2.9
Narasimha with Lakshmi

immortal, is killed, his arrogance shattered.

The son adores Narayan but also fears this creature who drinks his father's blood. Image 2.9 shows a more gentle form of Narasimha. One fears that Narasimha in his violent form will destroy the world; so, Goddess Lakshmi appears before Narasimha and reminds him of his responsibility to protect her and calms him down. This image shows Narasimha with Lakshmi, the guardian and his ward, God and Goddess, adored by Prahalad and four gods who perhaps represent the four books of Vedic wisdom, or perhaps the four goals of worldly life: dharma, artha, kama and moksha.

Prahalad's father is described as a demon, but the son is not considered one. Both are Asuras, but contrary to popular belief, all Asuras are not demons. It is intent and behaviour that can make anyone a demon. Hiranakashipu is arrogant and this arrogance comes from power. In arrogance, he assumes that he has knowledge of all possibilities. He knows everything. But the wise know that the human mind is finite and cannot hold the infinite expressions of the cosmos. Like Narasimha, who is neither this nor that, or perhaps both, there is much in the world awaiting discovery.

Narasimha sits on the coiled serpent, representing the stillness that is required to sense the presence of consciousness. Here, God is united with the Goddess, spirit and matter are together. Behind them is the split pillar, the split of matter and spirit, the split between our flesh and our soul.

Image 2.10 is a visualisation of a scene prior to the narration of the *Bhagavad Gita,* one of Hinduism's most popular religious texts. Literally translated, 'Bhagavad Gita' means the Song of God. Here God takes the form of Krishna, who serves as

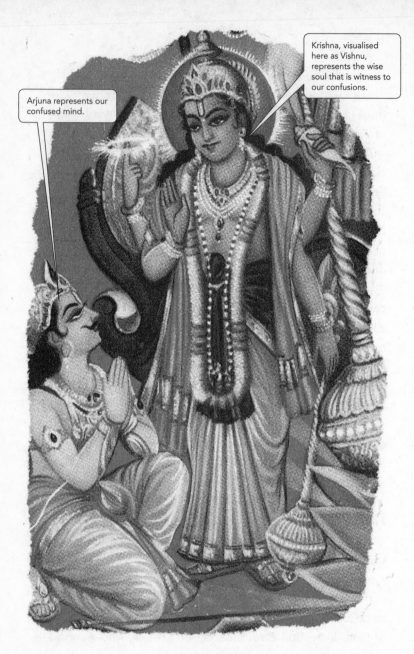

Image 2.10
Arjun seeking Krishna's advice

charioteer to Arjuna, a great archer who is suddenly confronted with the awesome reality before him — he is about to begin a war over property and principles in which he will be expected to kill family and friends. And God is asking him to do it. How can he? Why? He refuses to fight. He turns to Krishna for guidance and, in response, Krishna speaks to him words that enlighten and empower him.

Krishna explains to Arjuna the nature of the world. He draws attention to the soul that is imperishable and matter that is ever-transforming, hence giving the impression of birth and death. Things die only to be born again. What then is the purpose of life? The Gita reveals that matter exists to draw our attention to the soul, to make us aware of that permanent, unchanging principle. And to realise it, we have to negotiate our way through life, through society. We have to function as members of society, do our duties, fight for what we believe is right, and surrender to the wisdom of the cosmos. Life is about living, about participating, and escape is not an option. Actions born of desire, we are told, entrap us in a never-ending wheel of birth and death. Escape is possible if one is willing to discipline the mind, rein in desire and act dispassionately, doing one's duty, stripped of any desire to dominate the world or indulge the ego.

Enlightened by Krishna, Arjuna asks him to show his true form, for it is very evident that Krishna is no ordinary mortal. Krishna then shows his Vishwarupa or cosmic form, also known as Virat-swarupa, the all-inclusive expansive being that he is. This is depicted in Image 2.11. Arjuna observes that within Krishna are all the gods and all the demons and all the sages and all the hermits. He is the sun and the moon, he is the stars and the planets, he is the rivers and the fires. He is what was, is

Image 2.11
The cosmic form of Krishna

and will be. He is all forms. He is all directions. He is all that is possible and all that is impossible. Arjuna sees Krishna exhaling life and inhaling death. Whole worlds emerge from his mouth and are ground by his teeth.

This is the Hindu idea of God. God is all things. He is in all things. He is outside all things. He is She. He and She are also it. That which is animate and that which is inanimate — everything is God. The human, the subhuman, the superhuman — all are God. God is formless and is expressed through all forms. All that we see is God. All that we sense is God. God is not out there. He is within us and around us. He is all there is. We are the observers who create the observation that is life. We are thus not separate from our lives. We and our world are the same. This is Advaita or non-duality of being.

We are God too — we just have not discovered the truth of ourselves. We are limited by our egos, our imperfect understanding of the world, our prejudices and our memories. We need to break free from all this, from ourselves. And, according to the *Bhagavad Gita,* this is possible only when we live life, struggle with the rules, the moralities and the ethics that the world subscribes to.

And when we die, we should know that we will be reborn. There will be another life, another chance to open our eyes and look at a new world with a new set of eyes. With this new set of eyes will come a new way of looking at things, new rules and new prejudices. Once again the lotus of Brahma will rise from Narayan's navel as in Image 2.12. Once again, Lakshmi will demand attention and protection. Once again Narad and Tumburu will fight to possess her and Narad will stir us into jealousy and outrage. We will struggle to maintain order, flying

Image 2.12
The primal sleep of Narayan

around on Garuda and disciplining ourselves like Hanuman: a new awakening and a new world order, another chance to get it right.

Since the Hindu world is going through cycles of life and death, this life is but one of the many lives to lead. There is therefore no dominant urge to be a hero. There is no sense of urgency. And since all things depend on points of view, there is a lack of certainty in all things. All things are relative and contextual and impermanent. One yearns for that which is absolute, permanent and independent of all contexts. That is the soul — the soul whose sleep leads to destruction and whose awakening leads to creation, whose observation gives shape to the world. The discovery of the one who creates the world, that observer, is the purpose of life.

3
ARDHANARI'S SECRET
God is stillness within,
Goddess is movement around

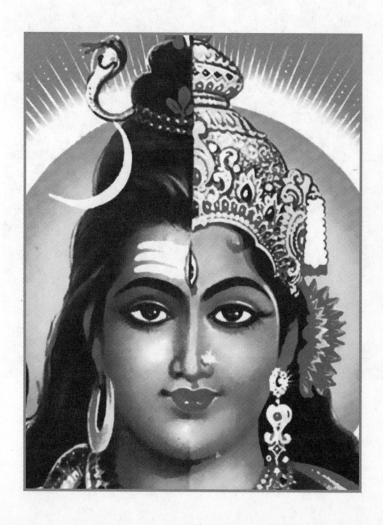

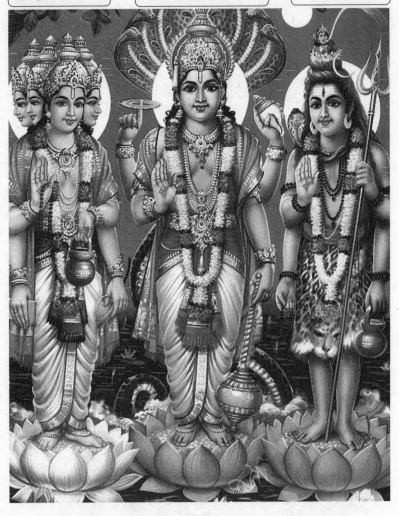

Image 3.1
The divine as male trinity

God in Hinduism can be nirguna (without form) or saguna (with form). Any representation of God with form is bound to be imperfect, as no form is perfect. If God is visualised as a plant, then it excludes animals and minerals. If God is visualised as human, it excludes plants and animals. If human, should it be man or woman or a combination of both? For Hindus, God is never limited to one form. The idea of God is expressed through plants, animals, minerals, humans (male and female) and even forms that combine various beings. For most Hindus, God is best embodied in the form of three human couples: Brahma and Saraswati, Vishnu and Lakshmi, Shiva and Shakti.

Image 3.1 visualises the Hindu male trinity. Brahma is the creator, Vishnu is the sustainer and Shiva is the destroyer. Brahma, with four heads and a book, looks like a priest; Vishnu, with four arms holding a conch-shell, disc, mace and lotus, looks like a king; Shiva, with his trident, looks like a mendicant.

Image 3.2 visualises the Hindu female trinity. Lakshmi, Saraswati and Shakti embody wealth, knowledge and power. Lakshmi is dressed in red and holds a pot; Saraswati is dressed in white and holds a lute; Shakti holds weapons and rides a lion.

If one observes these images carefully, the male trinity is associated with verbs: creating, sustaining, destroying. The female trinity, on the other hand, is associated with nouns: knowledge, wealth, power. The Gods are doing. They can create, sustain or destroy. The Goddesses are passive. Wealth, knowledge and power can be created, sustained or destroyed. One has to ask the question at this point — is the gender of the image the 'signifier' or the 'signified'? Must we focus on the form of the symbol (the gender) or the idea being symbolised through them?

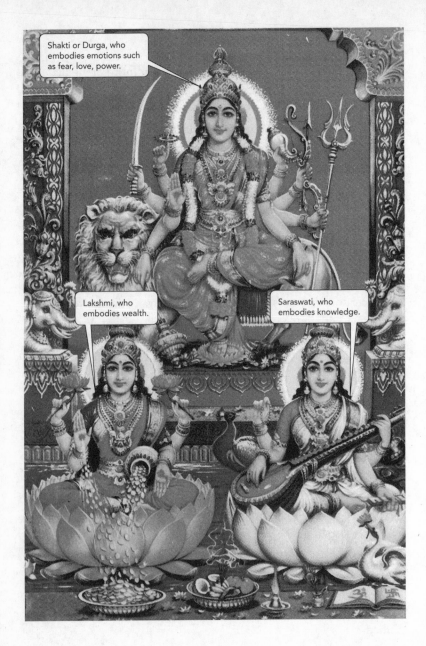

Image 3.2
The divine as female trinity

If we focus on the form and assume that the signifier (form) and the signified (idea) are the same, then it means that the image is a patriarchal one, telling us that men are active subjects (the ones who do things) while women are passive objects (the ones to whom things are done). But such interpretations satisfy only feminist, patriarchal and socialist ideology based on binaries — male/female, powerful/powerless, victim/victimiser, master/servant.

There is an alternate way of seeing these images: to focus on the idea behind the form. When that is done, we realise then that the male triad signifies the individual, the observer, the one who acts, the one who senses, the one who responds — the spiritual reality that is within us! We create, sustain and destroy, regardless of whether we are men or women. The female triad then signifies the observation which stimulates and provokes reaction and is a recipient of reaction — the world created by mind and matter, our world of thoughts, emotions and sensations. The Gods are within all of us. The Goddesses are around all of us. We can create, sustain or destroy wealth, knowledge and power. We can use, abuse or misuse wealth, knowledge and power.

The next question is: why is the male form used for the spiritual subject while the female form is used for the material object? To understand this, we have to understand the difference between material reality and spiritual reality. Material reality is that which is contained within space and time. That which cannot be contained by space and time is spiritual reality. Material reality has form; hence, it is measurable and is 'contained' within a 'container'. Spiritual reality is formless and immeasurable; hence, it is not containable. The human male physiology, for

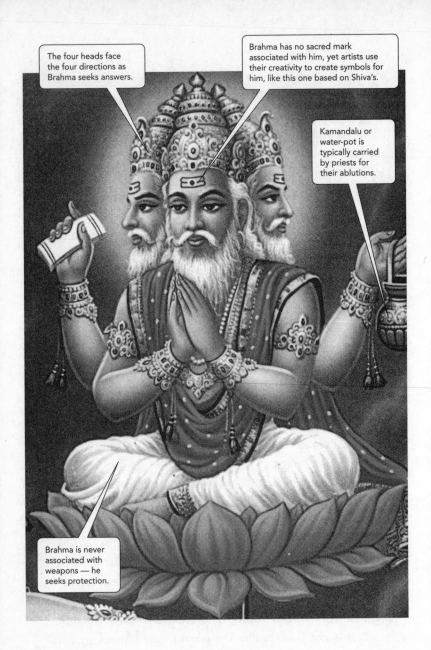

Image 3.3
Brahma, the creator

example, creates life outside itself. On the other hand, life is created within the human female's body. Thus, the female form best represents the container, the source of all things material. The woman becomes the symbol of material reality, making man the symbol of spiritual reality. Unfortunately, society has corrupted the meaning, and representations have become reality. Rather than saying that women represent material reality and men represent spiritual reality, we say women are material reality and men are spiritual reality. This creates political and ideological conflicts. We need to be aware of the way we express these thoughts and realise the myth beyond the mythology.

Our soul or consciousness can be creative (Brahma in Image 3.3), sustaining (Vishnu in Image 3.5) or destructive (Shiva in Image 3.7). Mind and matter can be intellectual (Saraswati in Image 3.4), economic (Lakshmi in Image 3.6) or emotional (Shakti in Image 3.8). Spiritual reality or God is best expressed through negation, neti-neti or not this, not that. Material reality or Goddess is best expressed through affirmation, iti-iti, this too, that too.

Wealth, knowledge and power do not discriminate between the rich and the poor, the beautiful and the ugly, the upper classes and the lower classes. A bowl of rice will satisfy the hunger of a king as well as that of a beggar. He who seeks knowledge, whether a policeman or criminal, will gain knowledge. Power is available to the worthy. The Goddess does not discriminate; she represents an absence of judgement.

The capacity to judge is embodied in male forms. God creates, sustains and destroys society. He is the fountainhead of values, morality and ethics. The Goddess can be measured. But

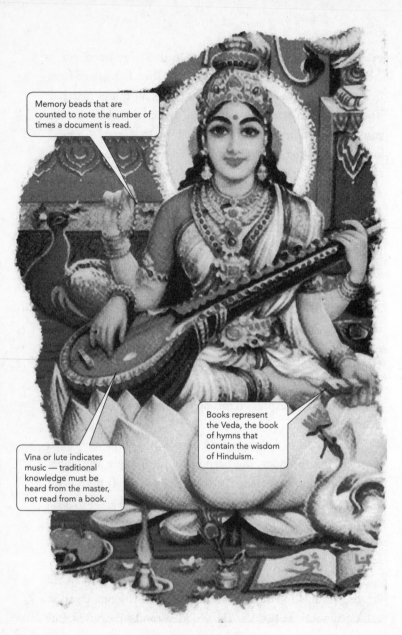

Image 3.4
Saraswati, the Goddess of knowledge

the measurer and the measurement scale are created, sustained and destroyed by God. The Sanskrit word for measurement is maya — that is why the Goddess is called Mahamaya, the great one who can be measured and evaluated. She is matter, she is energy, her various forms are created, sustained or destroyed by the one who observes her.

When Narayan wakes up, the Goddess is observed through the senses. She is classified using words, limited by thoughts, and measured with scales. Suddenly, she is evaluated and judged. These forms, names and evaluations enchant us, entrap us, delude us, stir our passions, make us happy and sad because they are never still. That is why this material world of changing forms is often referred to as maya, the embodiment of delusion. She is the world that we experience. As she keeps changing, we struggle to control her, hold her still and make her permanent, but we fail, for her essential nature is to transform.

That we experience the Goddess makes us appreciate that which does not change — the still, the serene, the silent soul within us, God. That we experience the restlessness of Maya, makes us realise there is Atma, the soul, watching the dance of the enchantress. That we experience nature, Prakriti, swallowing and spitting out life, makes us seek Purusha, the silent witness to the games of life.

The Upanishads, ancient Hindu scriptures dating to 500 BC, constantly refer to these two truths: a truth which changes and a truth which does not change. The existence of one points to the existence of the other. In change we seek permanence. In restlessness we seek restfulness. In movement we seek stillness. In sound we seek silence. The idea of the two complementary truths reaches us all through history and geography with a variety

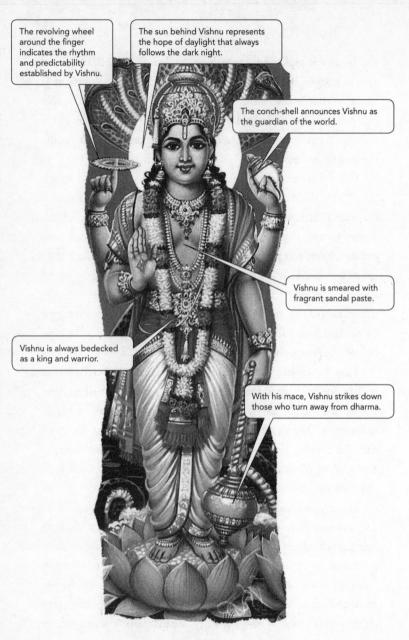

Image 3.5
Vishnu, the preserver

of plant, animal, mineral, geometrical and human symbols.

All plants grow and change over time but some more than others. At one extreme is the banyan tree. It has a long life, and, while it provides shade, it does not feed human beings. At the other extreme are grass and grain — they have very short lives and they provide no shade, but they provide food. The former represents the unchanging truth — it gives us spiritual shade when life becomes unbearable, but it is unable to create or sustain life. The latter represents the changing truth — it sustains the body, but it is unable to give a sense of permanence or stability. In Hindu rituals related to childbirth and marriage, one finds a lot of importance being given to grain and grass and to the banana tree. But there is no sign of the banyan tree or even a banyan leaf, which is restricted to respected ascetics outside the framework of the household.

In the animal kingdom, the idea of the still spiritual soul and the moving material world is best represented through the cobra. All animals move, but only in a cobra is there differentiation between movement and stillness in an image. When still, a cobra coils itself and raises its hood. In order to copulate, both the male and the female have to constantly move. Thus, a hooded cobra — associated with the meditating Shiva or the sleeping Narayan — represents the unchanging, otherworldly truth, while a pair of copulating serpents is a fertility symbol associated with a changing, worldly truth.

In the mineral world, the best way to represent stillness is with ash and snow. Ash is created when something is burnt or destroyed, but ash itself cannot be further destroyed. Thus it represents permanence — the unchanging truth, the soul. Snow is water that is still. Both ash and snow are associated with the

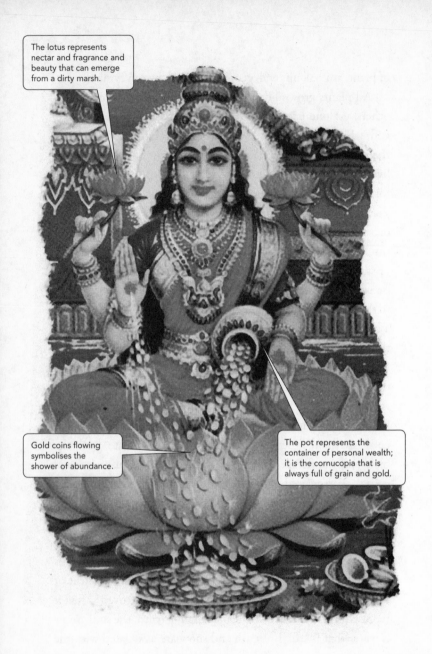

Image 3.6
Lakshmi, the Goddess of wealth

hermit Shiva who sits still on the Himalayas. If snow is still water, then the river is moving water, and best represents the changing truth, the impermanent world. One can never step into the same river twice, as the wise say, for she is always changing. Shiva stills the flowing river-nymph Ganga in the locks of his hair because she has the power to overwhelm the world and the mind with her flow.

In geometry, triangles are used both to represent stillness and movement. An upward-pointing triangle is used to indicate stability, and a downward-pointing triangle is used to indicate movement. This is expressed best in Image 4.15. Amongst colours, white is the colour of stillness because it reflects all the colours of the spectrum. Saraswati (Image 3.4) wears white. Black is the colour of movement because it absorbs all colours. Red is the colour of potential energy, while green is the colour of realised energy because the earth is red just before the rains, when it still contains sown seeds, and it is green after the rains, when seeds burst forth into life. Typically, Lakshmi (Image 3.6) and Durga (Image 3.8) wear red robes, while Annapurna (Image 1.14) is dressed in green.

In space, the Pole Star is still, hence the northern direction came to be associated with stillness and wisdom and immortality, while the southern direction came to be associated with change and death.

In the body, the left side represents change because even when we are still, the heart continues to beat against the chest. The right side by contrast is still, thus representing the soul. Since change is undesirable, the left side became the inaus- picious part, and the still right became the auspicious part of the body.

Amongst humans, the celibate hermit represents the still

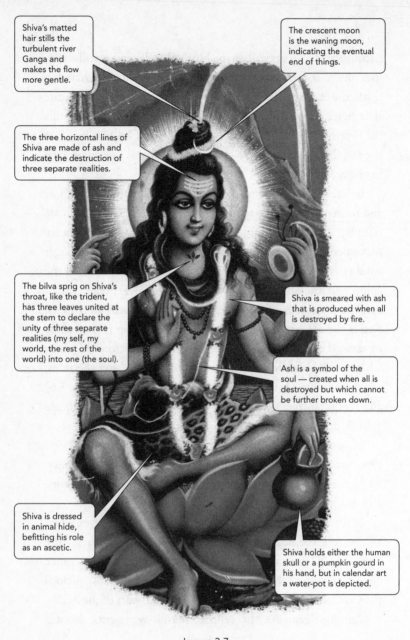

Image 3.7
Shiva, the destroyer

soul, while the dancing nymph represents the moving world. The two are constantly in conflict. Yet only when the hermit and nymph unite is life created. Thus life is a mix of the changing and the unchanging truth. Image 3.9 represents the combination of the unchanging truth (left-sided male ascetic) and the changing truth (right-sided female dancer).

Image 3.9 of Ardhanari-eshwara or God as half a woman is very popular. It has led to psychoanalysts to conclude that Indian culture was very comfortable with female sexuality; it was a part of the divine. Few cultures in the world saw the divine in feminine form. Fewer still saw the divine as partly masculine and partly feminine. It is easy to see this image and assume that India is comfortable with sexual ambiguity — the woman in man and the man in woman. But these are assumptions and, unfortunately, do not convey the truth of the society. Yes, India has culturally accommodated men with ambiguous sexuality — hijras, transgendered men and women — but they exist in the periphery of society.

Unfortunately, we live in a world where people focus on form rather than idea; we assume representation is reality and Ardhanareshwara is decoded as a half-woman god rather than the divine, which is half-matter and half-spirit.

In symbolic language, the male half represents the formless divine known in Vedas as Purusha, in Vaishnava manuscripts as Narayan and in Shaiva manuscripts as Shiva. The female half represents the divine that has form (male, female and neuter forms). The female form is known in Vedas as Prakriti, in Vaishnava manuscripts as Maya and in Shaiva manuscripts as Shakti.

This image is interesting as the identity is very much masculine

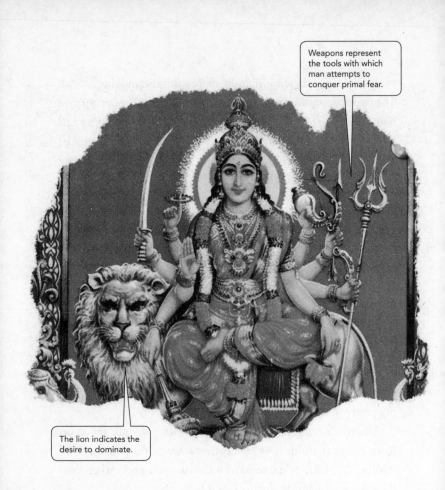

Image 3.6
Shakti, the Goddess of power, love and emotions

— this is a half-woman god, not a half-man goddess. There is no reference to any half-man goddess in sacred literature. Thus, within the apparently inclusive form of the divine is a gender power play. This is a form of Shiva, the ascetic god.

The story goes that Shiva's devotee, Bhringi, wanted to circumambulate Shiva but not Shiva's consort, Parvati. Parvati would not allow that. She sat on Shiva's lap, making it impossible for the ascetic to pass between them. When Bhringi took the form of a bee to fly between their heads, she merged herself with Shiva, so that she became his left half. Now Bhringi took the form of a worm and tried to bore his way between them. Parvati was not amused. She cursed Bhringi to lose every part of the body given to him by his mother. As a result, the ascetic was left with neither flesh nor blood (the soft parts of his body). Reduced to a skeleton, he could not stand upright. Taking pity on him, Shiva gave him a third leg so that he stood like a tripod, reminding everyone of the price man pays if he does not revere the feminine half of the divine. This is a Tamil temple lore from the southern part of India.

Another story of this image comes from the Himalayan region in the north. When Parvati saw Ganga, the river-goddess, on top of Shiva's head, she was furious. How could he keep another woman on his head when his wife sat on his lap, she wondered. To pacify Parvati, Shiva merged his body with hers. He became half a woman.

Why is the image that of a male god? The image suggests that Shiva is incomplete without the Goddess, meaning that spiritual reality is incomplete without material reality. One is asked to worship spiritual reality (Shiva) because we are distracted by all things material (Shakti). The tendency is to look down upon

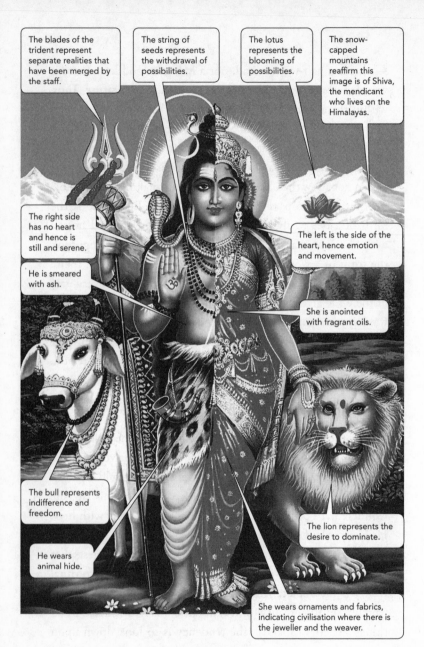

Image 3.9
Ardhanari, the half-woman god

all things material — to denounce sensuality and temptation. But by giving due reverence to the Goddess, the image is trying to remind us that through material reality alone can we realise spiritual reality. Material things currently hold primary value in our lives. The sacred image gives secondary value to the material half by placing it on the inauspicious left side.

In image after image, we will find the continuous discourse between the left and right side of images, which in effect is the discourse between the material and spiritual halves of reality. Ganesha (Image 1.17) will always be shown with his trunk turned to his left half; Shiva (Image 4.13) will always be seen standing on his right foot; and Vishnu, as Krishna, will always be shown suckling his right toe (Image 2.7) or placing his right foot over the left leg (Image 6.21), reminding us that our life is a continuous dialogue between the divine within and the divine without, between God and Goddess, for without either there is neither.

4
SHIVA'S SECRET
Withdrawal leads to destruction

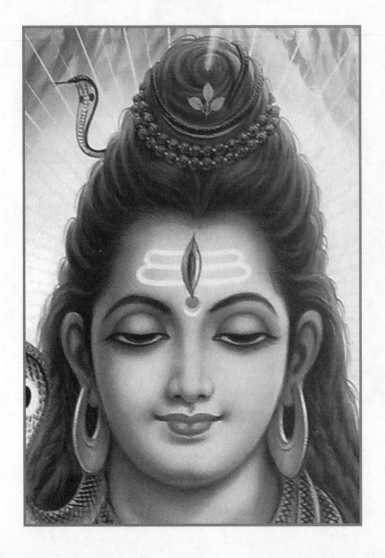

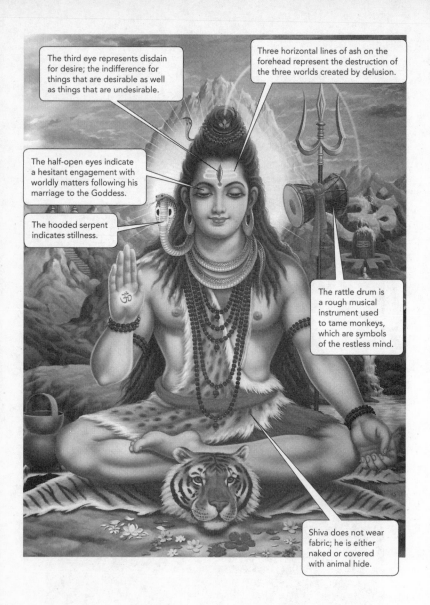

Image 4.1
Shiva, the destroyer

Image 4.1 shows a mendicant draped in animal hide seated in a cave atop a snow-clad mountain. This is Shiva, commonly known as the destroyer. Shiva destroys, but what does he destroy? Conventionally, destruction is linked with the breakdown of things, with rage and anger. But this deity is calm and composed, lost in his own world. His eyes are downcast, half-shut, as if he is not interested in looking at those who seek his audience. He is withdrawn. How can he be a destroyer?

The problem lies with our understanding of destruction. What does Shiva destroy? Sacred scriptures tell us repeatedly that he is Kamataka, Yamantaka and Tripurantaka — destroyer of Kama, destroyer of Yama and destroyer of Tripura, which means destroyer of desire, destroyer of death and destroyer of the three worlds.

With his third eye, he releases a flame that reduces Kama into a heap of ash. Kama is the god who makes us want things. Shiva destroys the one who provokes desire. Shiva wants nothing. Shiva also destroys Yama, who supervises the death and rebirth of man. Yama is the keeper of karmic accounts. By destroying Yama, Shiva destroys karma, that which rotates the wheel of life. With the end of Yama, there is no death, there is no rebirth, and the wheel of life grinds to a halt. When Kama and Yama are destroyed, Tripura or the three worlds are destroyed. What are these three worlds? The Vedas say they are the earth, the atmosphere and the sky. The Puranas say they are the earth, the land below the earth and the land above the sky. Perhaps these worlds are not objective at all — they are subjective, the worlds created by our thoughts and feelings. Thus the three worlds are our private world, our public world and all the rest there is. Shiva destroys our desire for life; he destroys our fear of death;

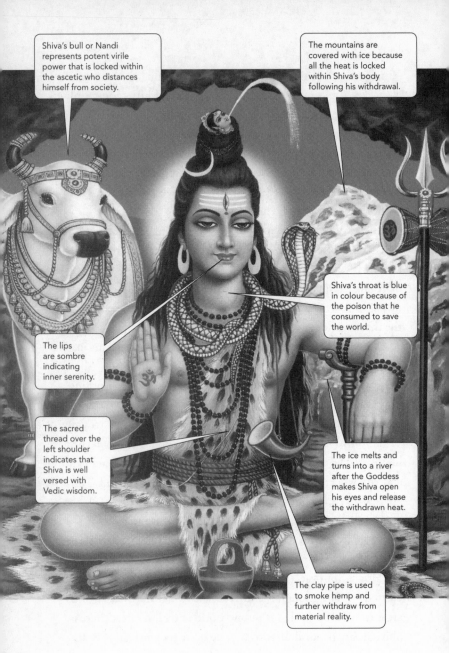

Image 4.2
Shankara, the benevolent one

he destroys our need for the world around us.

Ash is the symbol of destruction as well as permanence, for it is created by burning things but cannot be burnt itself. Thus, it is also the symbol of the immortal soul, released when matter is destroyed. Shiva is smeared with three lines of ash oriented horizontally. These refer to the three destroyed worlds and the horizontal orientation of the line suggests entropy, inertia, lack of movement, a state of dissolution.

Shiva's trident, where three blades unite to form one staff, indicates the dissolution of the three worlds into one. In the Hindu world, creation happens when the subject and the object split, when there is a separation between the observer and the observation. Shiva destroys, and he does that by destroying the division between the subject and the object, between the observer and the observation. The three worlds become one, and the one is the self.

And how does he destroy? By shutting his eyes, by refusing to be an observer, hence not creating an observation. This is a visual representation of disconnection from the outside world; Shiva receives no sensory inputs. The shut eyes of Shiva indicate his indifference to the world, to Kama, to Yama, to Tripura. He is like the solitary bull standing behind him in Image 4.2 — potent, powerful, but totally independent, not part of society. He is not hiding from the world; he does not need the world. Like Narayan in deep slumber, he is self-contained. He is the supreme hermit — still and serene. The sense of stillness is reinforced again and again by the hooded serpent around his neck, the mountain on which he sits and the snow around him.

In stories, Shiva is naked and sports an erect phallus. Since such images would cause discomfort to the general public,

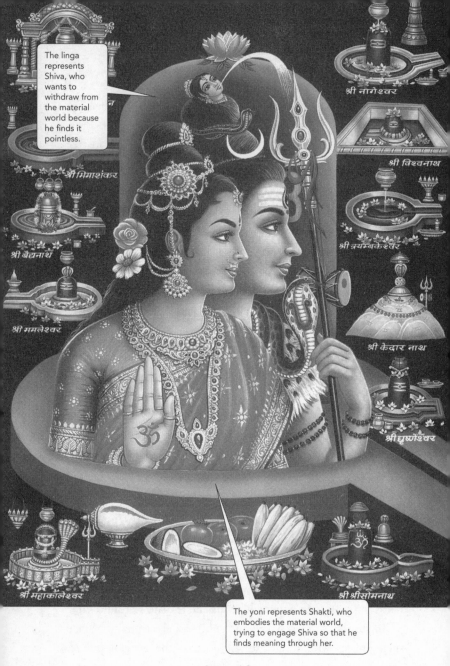

Image 4.3
Linga-yoni

Shiva is modestly draped in animal hide. The use of animal hide suggests that Shiva uses no manmade cloth. As a hermit, he wears what the wilderness provides.

Shiva's phallic symbol or Shiva-linga shown in Image 4.3 arouses a lot of curiosity. People are quick to conclude that it is a fertility symbol. Few wonder how a destroyer can also be a source of fertility. The simplest answer is to say he who destroys is also the creator. This means that the creator is also the destroyer. Then Brahma and Shiva should be one and the same. Why then is Shiva worshipped but not Brahma? Clearly, the creator creates something that makes him unworthy of worship, while the destroyer destroys something that makes him worthy of worship. The problem here is based on our paradigm. Once one learns Ganesha's secret (Chapter 1) and accepts that different people see the world differently, one will be in a better position to appreciate that the creator means different things to different cultures. In Hinduism, Shiva's destruction of desire and karma make him worthy of worship.

Shiva's erect phallus must be seen in the context of his shut eyes. Shiva, sitting alone without his wife, typically shuts his eyes. It is an image that appeals to hermits. But calendar art is for householders who prefer to see Shiva with his eyes open. To satisfy the devotees without compromising on Shiva iconography, artists typically draw Shiva with half-shut eyes. Shiva's shut eyes are of great significance. Normally, an erect phallus indicates arousal and is a reaction to a sensory stimulus. But since Shiva's eyes are shut, there are no sensory inputs. The arousal then is svayambhu, self-stirred, not the result of external stimulation, but the result of internal bliss. Thus, the erect phallus is not a visual representation of rasa or material joy, but of

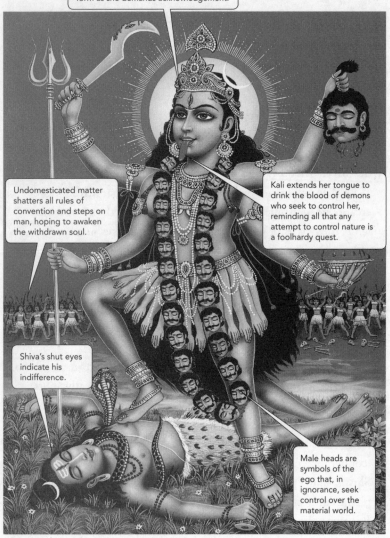

Image 4.4
Kali standing on top of Shiva

ananda or spiritual bliss, one born of self-containment. Thus Shiva invalidates the need for the observation. He does not value or care for the material world. In mythological terms, he does not need the Goddess. And that just will not do!

Just as the north cannot exist without the south, just as the left side cannot exist without the right side, just as stillness is meaningless without movement, observers have no meaning without observation. God needs Goddess. The destroyer thus must be made to open his eyes. That is why the Goddess transforms into her most primal form, Kali, and dances on Shiva.

Image 4.4 shows Kali, the naked Goddess (modestly covered for the sake of popular sensibilities), dancing atop a Shiva who lies indifferently on the floor. Shiva's position indicates a lack of effort, the state of entropy. Shiva does not care for the world. Nothing matters to him. She is naked, unadorned, pure, unaffected by the gaze of civilisation. She is determined to be seen. Kali wants Shiva to value material reality and care for it. She wants him to open his eyes, and become the observer.

Kali is movement, Shiva is stillness; Kali is vertical, Shiva is horizontal. Kali resides in the south, where death also resides as Yama, while Shiva resides in the north, as still as the Pole Star and the snow-clad mountains. Kali is woman creating life within, Shiva is a man creating life without. But unless Shiva copulates with Kali, no life will be created. So, she sits on top of Shiva as in Image 4.5, and forces him to create life within her. Here the Goddess holds all the images associated with Kama (a sugarcane bow and flower arrows) and Yama (axe and noose). Thus, the Goddess resurrects life and death. She rotates the wheel of rebirths so that once again everyone experiences the yearning for living and the fear of death. These two emotions

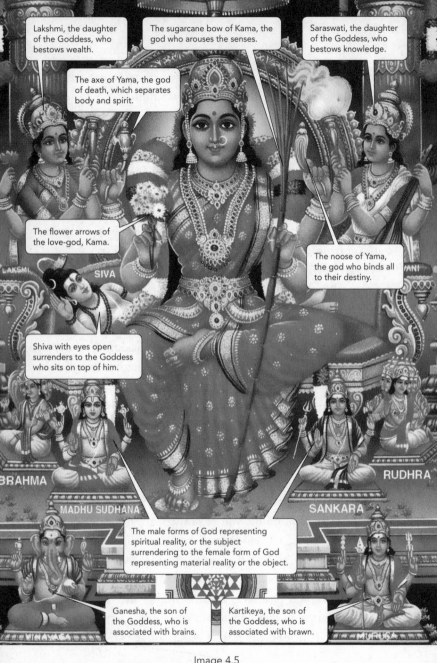

Image 4.5
Rajrajeshwari, the Goddess in all her splendour

make man chase wealth and wisdom, manifested as the two Goddesses, Lakshmi (dressed in red) and Saraswati (dressed in white), standing on either side of the Goddess. This form of the Goddess is called Tripurasundari, the one who embodies the beauty of the three worlds, the very same worlds that Shiva destroyed, whose ash smears his forehead.

The Goddess in Image 4.4 looks very different from the Goddess in 4.5. In the former, she is wild, naked, dark and violent. In the latter, she is domesticated, dressed, fair and loving. In the former, Shiva is refusing to open his eyes. In the latter, he has opened his eyes. In the former, the Goddess is full of rage because the soul is indifferent and the world has to cope with the restlessness of the mind, with pride, with insecurity, with the ego. In the latter, the Goddess is content because the soul is paying attention, the mind is restful and the ego is tame. Image 1.1 shows that God and Goddess have created children, two sons: the elephant-headed Ganesha and the spear-holding Kartikeya, the former associated with prosperity and the latter associated with power.

In both these images, God takes an inferior position to the Goddess. Some scholars believe that this indicates that the Shakta sect was matriarchal unlike the Shaiva and Vaishnava sects of Hinduism, which were dominated by male deities. However, from a symbolic point of view, it indicates a school of thought that values material reality as much if not more than spiritual reality. It indicates equal, if not more, respect being shown to fertility cults and to household rites in a land that was increasingly turning monastic.

Image 4.6, which depicts Shiva getting married, is popular in south India. This image is often found on temple walls. The

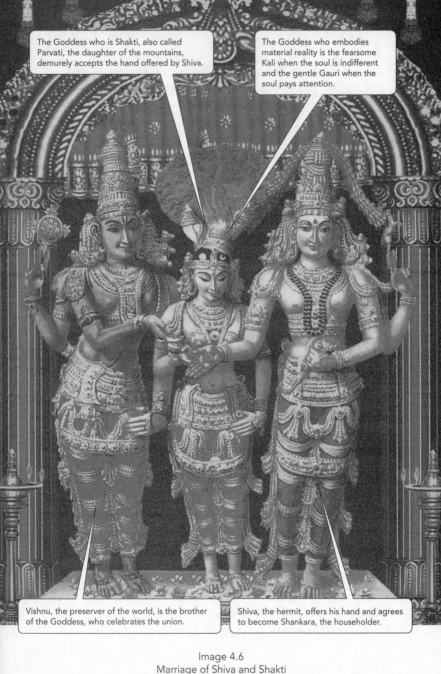

Image 4.6
Marriage of Shiva and Shakti

bride is the Goddess and the one standing on her right, giving her away, is Vishnu, locally identified as the brother of the Goddess. Vishnu plays the role of the preserver. He knows that so long as Shiva is a hermit, the world is threatened by indifference and destruction. Shiva needs to be engaged with the world and marry the Goddess. In the image, Shiva is bedecked in finery, indicating that he has shed his hermit ways. He is becoming Shankara, more aligned with the ways of the world. This was not always the case.

Image 4.7 shows various events from Shiva lore drawing attention to his transformation from the hermit to the householder. Shiva's first marriage was a disaster. His wife, Sati, was the daughter of a priest, Daksha. Sati followed her husband everywhere, accepting him for who he was. But her father found her choice unbearable. Shiva's ascetic ways did not appeal to him, and so, when he decided to perform a sacrifice, he invited everyone to partake of it — except Shiva. Furious at this insult, which Shiva did not even notice, Sati killed herself at the sacrifice. In rage, Shiva beheaded his father-in-law after destroying his sacrificial altar. Here, he played the role of a conventional destroyer — destroying a social order that made no sense to him. This event is the first to show Shiva responding to an external stimulus. By following Shiva, the Goddess, as Sati, makes Shiva care for her so much that when she dies violently, he is filled with emotions of outrage and a desire for vengeance. For an ascetic who refused to open his eyes, this is a huge transformation.

Image 4.8 shows Shiva carrying the corpse of Sati, weeping like a lover. After the death of Sati, Shiva once again withdrew into his cave and the gods once again conspired to get him

Image 4.7
Shiva's lore

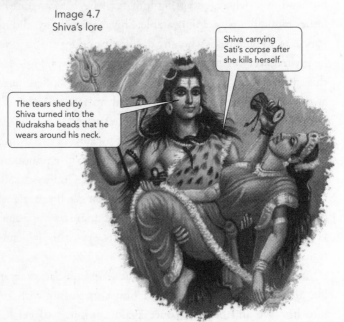

Image 4.8
Marriage of Shiva and Shakti

married. They sent Kama, the god of desire, to shoot his arrows at Shiva. But rather than being aroused, Shiva killed Kama with a fiery missile sent from his third eye. Shiva, who had experienced the turbulence of emotions because of Sati, was not going to surrender to it once again. Sati was reborn as Parvati, the princess of the mountains. She prayed to Shiva. She meditated intensely, forcing him to leave his cave and come before her. 'What do you seek?' he asked. 'You as my husband,' she said. Her determination and devotion were so great that Shiva had to agree. Thus, Shiva connected with the Goddess not out of desire, but out of grace. She induced him to become benevolent. With this, he became the householder. He became Shankara.

Image 4.9 also shows Shiva as a groom making his way to the house of his wife-to-be. Being a hermit, he did not know how to dress or behave like a groom. He came drunk, smeared in ash, with an entourage of ghosts and goblins. Across the Himalayan region, there are many folk stories of how Shiva's marriage party terrified the local residents and how, looking at him, Parvati's mother, Mena, wife of Himavat, the king of the mountains, begged her daughter to reconsider her decision. Finally Parvati begged Shiva to accept worldly ways and be a more presentable groom. He indulged her and became a beautiful god, Somasundara, as beautiful as the moon, and married the Goddess. The story draws attention to how Shiva, or the soul, does not discriminate between the beautiful and the ugly, between man and ghost, between cows and dogs. While this is a very lofty concept, this does not make sense within the social framework. In society, there are standards and values. There is the good and the bad, the beautiful and the ugly. There is the right and the wrong. There is, in other words, judgement. Judgement

Image 4.9
Shiva, the groom

Image 4.10
Shiva drinking poison

Image 4.11
Shiva stopping Yama,
the god of death

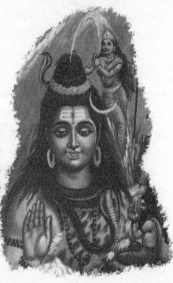

Image 4.12
Shiva catching Ganga in
the locks of his hair

is impossible without standards. For the hermit, these standards may seem cultural delusions, but for the householder, these are essential cornerstones of civilisation.

Image 4.10 shows the power of Shiva, now put to worldly use, thanks to his marriage. With his eyes opened by the Goddess, he is open to responding to the cries of the world. Once, the gods churned the ocean of milk for amrita, the elixir of immortality. While doing so, a deadly poison that threatened to destroy the whole world emerged. No one had the power to consume the poison. So the gods approached the one form of God that does not distinguish between poison and elixir. Shiva indulged the gods, consumed the poison and saved the world. While Shiva the hermit could consume the poison, Shiva the householder could not be allowed to have the poison as part of his system. So the Goddess clasped Shiva's neck, restricting the poison to his throat. The poison remained there, turning his throat purple. Thus he is also known as Neelkanth or the one with the blue throat.

In another instance, shown in Image 4.11, in response to the prayers of a young devotee, Shiva stopped Yama, the god of death, from killing a youth, Markandeya, who was fated to die at the age of sixteen. Shiva overturned fate, reinforcing his status as God, a force that is greater than fate.

When the river-goddess, Ganga, descended from the heavens, he caught her on his head and trapped her in his hair, thereby absorbing the shock of her fall. He then released her slowly, making her spring out of his topknot, as shown in Image 4.12. This river gave life on earth. When their ashes are immersed in this river, the dead are enabled to be reborn. The river represents the material world that on the positive side

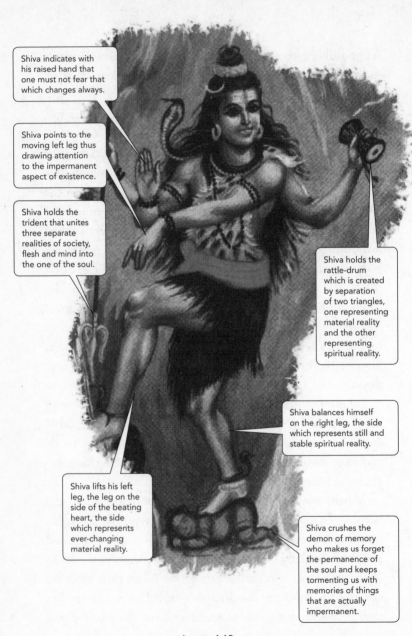

Image 4.13
Shiva as Nataraja, lord of dance

offers the chance of rebirth and which on the negative side breeds sorrow by constantly changing. By controlling the flow of the river, Shiva symbolically takes the role of the yogi, one who is able to control the mind so that it is not a slave of matter.

These three stories indicate the transformation of Shiva to Shankara. Married, he is worldlier. He saved the world by drinking poison, he bestows longevity and he helps the dead to be reborn. It is said that the moon was once cursed with a wasting disease and so it look shelter on Shiva's head. Contact with Shiva helped the waning moon wax again, for Shiva is the source of all potency. That is why the crescent moon is always shown on Shiva's forehead.

Image 4.13 shows Shiva dancing. This posture is the famous Tandava, which essentially means the more aggressive masculine form of dance, distinguishing it from Lasya, the more enchanting feminine form of dance. In this form, Shiva transforms into Nataraja, the lord of dance and theatre. This is a peculiar dance which he performed once when sages saw him walking naked with an erect phallus. Like most people, they did not see his eyes were shut, and assumed he was aroused by the sight of their wives. They tried to attack and kill Shiva; in response, Shiva danced. In this dance, he raised his left foot above the ground and pointed to the moving left foot with his left hand, while standing firm on his right foot. As mentioned in Ardhanari's Secret (Chapter 3), the left side is the side of the material world, while the right side represents the spiritual world. Shiva is Eka-pada, he who stands on one foot. He stands on his right foot because he is firm in spiritual reality. He indicates that our fears and insecurities emerge because we do not understand the nature of material reality — that it is transient,

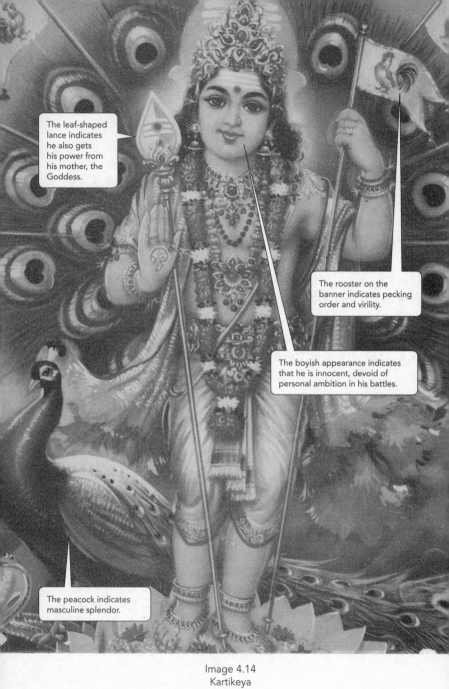

Image 4.14
Kartikeya

that it arouses and it depresses, it is the realm of rasa, stormy waves of positive and negative emotions.

Image 4.14 shows Shiva's son, Kartikeya. The story goes that the world was terrorised by a demon who could only be killed by a six-day-old child. To create such a powerful child, the gods needed the help of Shiva who — being an ascetic — had never shed semen, and this (according to traditional belief) had rendered his semen very potent. This was one of the reasons why Shiva's marriage was necessary. Shiva's semen, released after his marriage, was incubated by Agni, the fire-god, by Vayu, the wind-god, by Ganga, the river-goddess, and by Saravan, the forest of reeds, so that a six-headed child was created. He was nursed by the six Krittika stars and prepared for battle. Though a child, this divine warlord led the armies of the gods to victory.

The story of Kartikeya's birth must be contrasted with the birth of Ganesha retold in Chapter 1. Kartikeya is born of Shiva's seed and incubated by six material entities (fire, wind, water, reeds, stars and, finally, the Goddess herself), hence has six heads seen in Image 4.15. Ganesha's body is created out of the turmeric Parvati anointed her skin with and is finally completed when Shiva replaces his head with an elephant's. Both sons represent the union of God and Goddess, with the God taking the lead in Kartikeya's case and the Goddess taking the lead in Ganesha's case. But in both cases, Shiva is an unwilling participant. He has to be forced into fatherhood. Thus, the spiritual wants to disengage itself from material reality, while material reality wants to enchant it. This tension between the two generates the force that propels life.

Like Shiva, Kartikeya's relationship to marriage is ambiguous. In the north of India, he is considered to be unmarried, while in

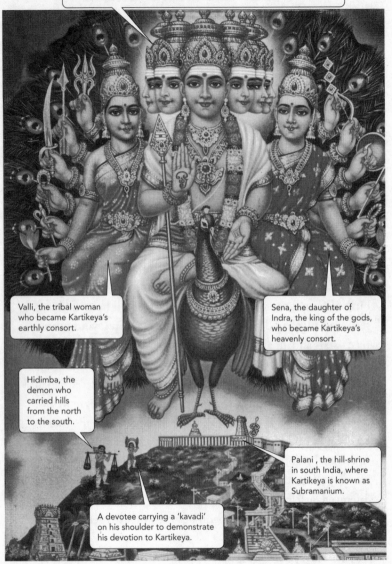

Image 4.14
Kartikeya as Subramanium

the south he has not one but two wives. Here too, marriage is a metaphor for engagement with material reality, with society. Kartikeya's wives in Image 4.14 and 4.15 are more popular in south India. They are Devasena, daughter of Indra, the god of the sky, and Valli, the daughter of a local tribal chieftain. Thus, the ascetic's son is wedded to the sky and to the earth. In many ways, this relationship is similar to that of Khandoba with his wives of various communities discussed in Image 1.7, and of Balaji with the local princess Padmavati discussed in Image 1.8. Thus, through Kartikeya, the transcendent metaphysical Shiva is localised and made more accessible in the hills of the south where he is mostly worshipped.

In north India, it is said that Kartikeya did not marry. The reasons are not clear. After the competition between him and his brother (described in Chapter 1), it is said that, in rage, Kartikeya refused to look at the face of any woman, even his mother. That is why in the few temples of Kartikeya in the north, no woman is allowed to enter the shrine. Kartikeya even left his father's house to stay away from his mother. He moved south, but soon began missing the northern hills. Feeling his son's homesickness, Shiva ordered a Rakshasa, a demon, called Hidimba to carry two hills from the north to the south. These hills are now pilgrim spots where Kartikeya is said to reside. In the south, he is worshipped either as Kumara, the bachelor, or Subramanium, the married god.

Image 4.15 shows two crisscrossing triangles. This is a geometrical representation of the union of material and spiritual reality. The upward-pointing triangle, like a mountain, represents stability, stillness and God. The downward-pointing triangle, like a waterfall, represents instability, movement and

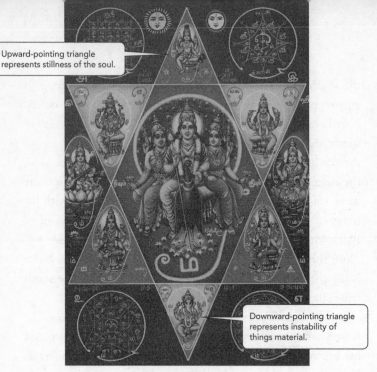

Image 4.15
Kartikeya depicted as a man with two wives

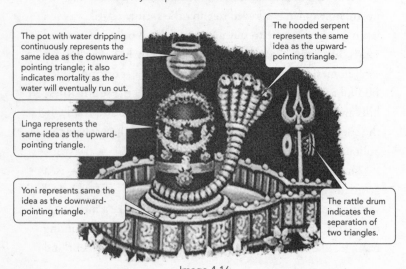

Image 4.16
Shiva's linga

Goddess. When they are separated, they look like Shiva's rattle-drum (see Image 4.1). But when united, they form a six-pointed star. Several such six-pointed stars are below the Goddess in Image 4.5. These are yantras or geometrical communications of metaphysical ideas.

The same geometrical form is rendered in three dimensions in Image 4.16. This image shows the Shiva-linga. The upwardly protruding pillar is conceptually the same as the upward-pointing triangle; both represent Shiva's erect phallus as he lies prone on the ground. The trough below on which the pillar stands is conceptually the same as the downward-pointing triangle; both represent the womb of the Goddess as she sits on top of him as implied in Images 4.4 and 4.5. Thus, it is the union of the changing truth of matter (downward-pointing triangle/yoni) and the unchanging truth of the spirit (upward-pointing triangle/linga).

Pots without stable bases hang on top of the Shiva-linga. The base is punctured so that water drips continuously, to remind us that worldly life is about movement and life ebbs with each passing moment as water flows out of a broken pot. We have to use this finite time we have with us to discover the truth of spirit and matter, how when they engage there is creation and how when they disengage there is destruction.

5
DEVI'S SECRET
Desire and destiny create life

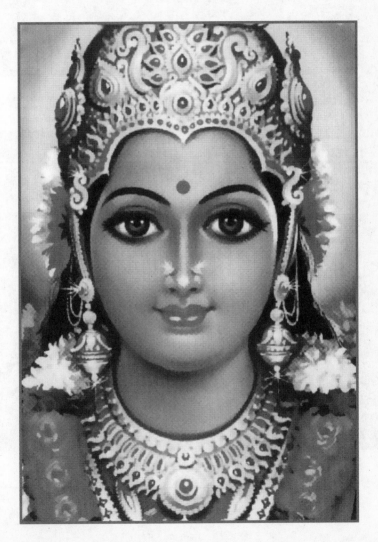

Image 5.1
Kanyakumari

Image 5.1 shows the image of a young girl holding a garland in her hand, waiting for her groom. This is Kanyakumari, the virgin goddess, and her temple is located in the southern tip of India. The story goes that Kanyakumari wanted to marry Shiva, the mendicant who lives atop the snow-clad mountains in the north. The hour of the wedding was fixed such that Shiva would have to travel from north to south in one night. However, before he could reach, the gods made a rooster crow. Shiva assumed it was daybreak and that he had missed the auspicious hour of marriage. So, he turned back. The goddess, bedecked in bridal finery, waited and waited for the groom who would never come. All the food that had been cooked for the wedding feast went to waste. In rage she kicked the pots and pans and wiped her face of make-up. That is why the sea and sands on the southern tip of India are so multicoloured. The goddess had a lot of power, power that would have been domesticated by marriage and maternity. Forced to live without a groom, the energy was then invoked by the gods to make the goddess fight and destroy demons. This story draws attention to the raw power that is the goddess. If she is married, this energy is channelised to provide for a home. If, however, she is not married, this energy is channelised for protection. As explained in Ardhanari's Secret (Chapter 3), the goddess is a symbol of the material world, the world that we observe through our senses. We want this world to be like a mother so that it can feed us; we want this world to be like a warrior so that it can defend us. So, the Goddess and her many diminutive doubles, the goddesses of households and villages, are mothers and warriors, loving and fearful.

Image 5.2 shows a village-goddess or Gram-devi. Only her head is seen. Her body is the village. The villagers live on top of

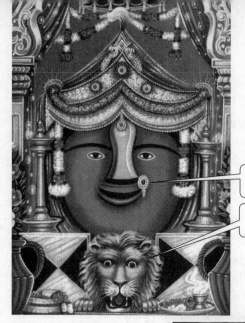

The nose-ring indicates she is domesticated.

The lion indicates she is still powerful and wild.

Image 5.2
Gram-devi

Cup to drink the blood of those who try to subjugate her.

Trident to pin down those who try to dominate her.

Fangs are a reminder of her primal wild nature.

Snakes point to her association with the earth whose fertility, like the serpent's skin, can renew itself at regular intervals.

Demon under her feet represents forces that try to domesticate her.

Image 5.3
Reclining village-goddess

her and they feed on her. They love and fear her. They know that beneath domesticity (orchards, fields, gardens) lurks wildness (forests). If she is unhappy she can show her rage by letting the forest slip into the village. This happens in the form of disease and death. When a woman miscarries, when there is an epidemic or when children suffer from high fever, the whole village looks upon it as the wrath of the goddess.

No village, no field, no orchard can come into being unless we destroy an ecosystem — unless we cut the trees of the forest, unless we plough the soil, break down the rocks, channelise the river. These are violent processes, a forceful domestication of the earth. Why do we domesticate? We domesticate because we can, because we are humans, because we have the ability to do so. And we use this ability because we desire a better life — where we are not at the mercy of nature for our survival.

Naturally the relationship between man and the other is based on desire. Desire can satisfy need or greed. Either way, nature is exploited. Man exploits nature to feed, clothe and shelter himself. He begs the goddess to allow herself to become domesticated and become a mother. But he knows she is wild and dangerous and can strike him down any time. In Image 5.3 is a village goddess from the south of India. Under her feet grovels a demon. Who is this demon?

One would not like to admit it, but this demon is man who seeks to destroy nature to establish his settlement. Typically, this demon has been externalised — he is the part of man that seeks to dominate the forest and make the goddess his mistress. He is the bad son. With him, the goddess becomes the bad, violent goddess. The good son adores the goddess. With him, the goddess turns into the good mother, full of bounty and joy.

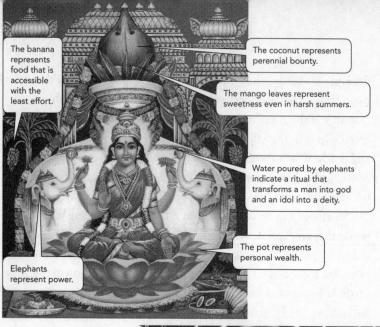

The banana represents food that is accessible with the least effort.

The coconut represents perennial bounty.

The mango leaves represent sweetness even in harsh summers.

Water poured by elephants indicate a ritual that transforms a man into god and an idol into a deity.

The pot represents personal wealth.

Elephants represent power.

Image 5.4
Lakshmi

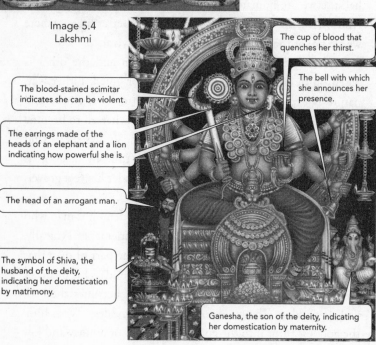

The cup of blood that quenches her thirst.

The bell with which she announces her presence.

The blood-stained scimitar indicates she can be violent.

The earrings made of the heads of an elephant and a lion indicating how powerful she is.

The head of an arrogant man.

The symbol of Shiva, the husband of the deity, indicating her domestication by matrimony.

Ganesha, the son of the deity, indicating her domestication by maternity.

Image 5.5
Bhagavati

She becomes the goddess in Image 5.4. This is Lakshmi, the embodiment of earth's wealth and bounty. She is a Goddess, unlike the goddess in Image 5.2 and 5.3, which means she is not localised to one place, but represents a wider metaphysical thought.

Lakshmi embodies wealth and fortune. As Shri, she brings splendour into our lives and makes kings out of men. As Bhu, she is the gentle earth, providing home and shelter to all her children. In this image she sits on a lotus, which represents all the best things that can emerge from the mire of life. She is flanked by white elephants, symbols of affluence and power, reserved only for the best of kings. In the background is a pot, the container of personal wealth, unlike a river or a pond, which is the source of all wealth. The pot is a sacred artefact. It represents the wealth that is contained within the confines of civilisation. It is not free wealth that exists in nature; it is wealth over which man has staked his claim.

Lakshmi is surrounded by plants that satisfy the hunger of man and pleasure their senses. Coconut and banana trees do not need much looking after, but they provide nutrition to all, making them sacred plants of high economic value and with very high return on investment. The mango leaves in the pot are a reminder of the sweet fruit that makes summer bearable, while the betel leaf beneath the pot is chewed after meals to aid digestion and also to act as an aphrodisiac. Thus, these plants are symbols of prosperity and pleasure. This is what man wants from the world, visualising the Goddess either in her local form, as in Image 5.3, or in a more global form, as in Image 5.4.

Image 5.5, in a way, merges the ideas in both 5.3 and 5.4. This is a local goddess from the state of Kerala known as Bhagavati.

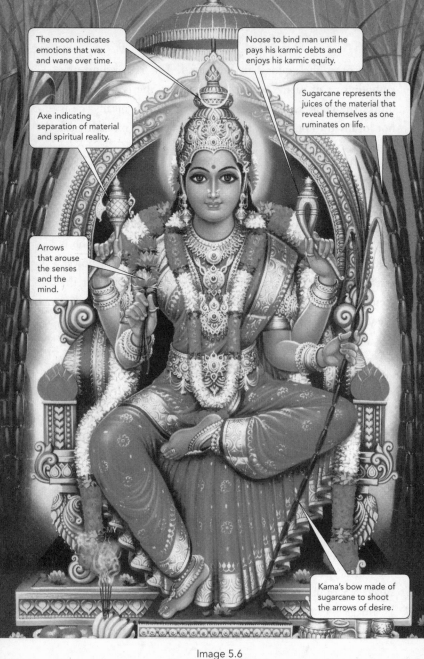

Image 5.6
Kamakshi

At first glance, the goddess is fearsome, with fangs and a blood-stained scimitar in her hand. She is the wild goddess who kills demons and drinks their blood. But then, we notice that on her right is a Shiva-linga, the symbol of her husband, and on her left is the elephant-headed Ganesha, her son. Thus, she is a form of Parvati, princess of the mountains. She is a local form of Shakti, the goddess of power.

Image 5.6 shows the Goddess as Kamakshi surrounded by sugarcane. Sugarcane is the symbol of love in India. It is also the symbol of desire and lust, all forms of sensory delight. She also holds a lotus in her hand. These are the weapons of the love-god, Kama. Riding a parrot, Kama holds aloft his fish-banner, raises his sugarcane bow, draws his bowstring of bees and shoots flowers-arrows that stir the senses, excite the heart and fill the mind with dreams and demands that often are at odds with destiny and with rules of good conduct. Kama, the god of desire, is a disruptive force. This is believed to such an extent that Hindus do not worship Kama anymore. But the idea of Kama survives when the Goddess comes to hold his symbols: his sugarcane bow and his flower arrow.

Desire is an important theme in Hinduism. In the Rig Veda, it is said that the world came into existence because desire for creation arose in the heart of the creator. A man's desire is fulfilled by engaging with the world. From the world come wealth, knowledge and power. Man can take all this from the Goddess, but the Goddess also asks him to give some things in return. She may be the object, the observation, but she demands that the subject, the observer, engage with her, not with the language of domination, but with the language of love.

In her two upper arms, she is holding an axe and a noose.

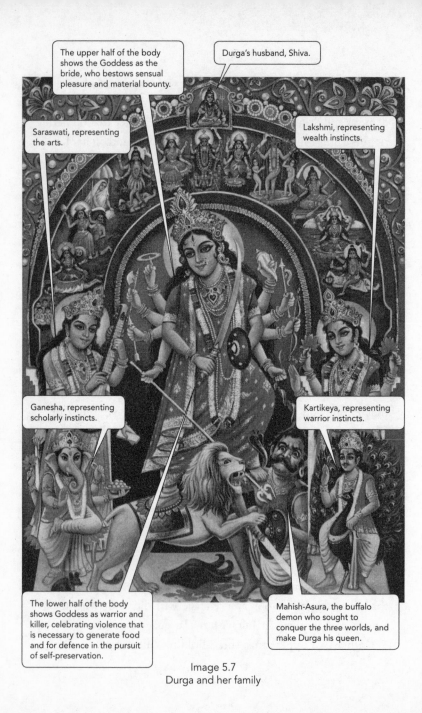

Image 5.7
Durga and her family

The axe is the symbol of death and division. The axe kills and separates the flesh from the soul. The noose, however, binds: it binds the flesh to the soul and it binds all living creatures to their fate. No one can escape fate. Even death is no escape from fate. The noose of fate forces us to live another life until it is time for us to fulfil our destiny. That is why we are reborn again and again; we are condemned to live with the body we are given and the circumstances around us. We do not choose whether we will be male or female. We do not choose whether our families will be rich or poor, loving or dysfunctional. We have no choice but to endure the vagaries of fate.

Fate in Hinduism is supervised by Yama, the god of death. Yama rides a buffalo and carries a noose. He maintains a book that records all our deeds. Every deed generates a debt or an equity. This is karma. We are obliged to repay our debt or enjoy our equity. As long as our account book is not balanced, Yama binds us with his noose. In Image 5.7, the Goddess is killing a demon who is also a buffalo. Though never stated explicitly, one wonders if the Goddess is killing Yama, the keeper of destiny. Is she liberating us from our destiny so that all our desires can be fulfilled?

The Goddess in Image 5.7 is Durga, the most popular form of Shakti, whose story is told in the *Devi Bhagvatam*. She is both power and love. Her face is made up like a bride but she carries in her arms weapons of war. As a bride, she is love; as a warrior, she is power. As a bride, she satisfies desires; as a warrior, she overpowers destiny. With her weapons, she defends us and feeds us, she makes us secure and she nourishes us. Thus, she embodies both power and love — the sense of being taken care of. That is why she is called the mother. The same image shows Lakshmi

Hanuman, the celibate monkey-guardian of the Goddess.

Bhairava, the boy-guardian of the Goddess.

Image 5.8
Vaishno-devi

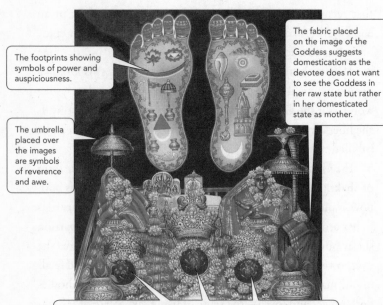

The footprints showing symbols of power and auspiciousness.

The fabric placed on the image of the Goddess suggests domestication as the devotee does not want to see the Goddess in her raw state but rather in her domesticated state as mother.

The umbrella placed over the images are symbols of reverence and awe.

The three rocks represent the three aspects of the Goddess: she enlightens (Saraswati), enriches (Lakshmi) and empowers (Durga)

Image 5.9
Vaishno-devi shrine

and Saraswati as the daughters of Durga — thus, power and love yield wealth and knowledge.

Durga rides a lion, the king of the jungle, the most dominant force in the forest, standing on top of the food chain. In Image 5.8, she rides a tiger. She domesticates the great cats and displays her power. Her name, Durga, means the one who cannot be conquered. Thus, she is the invincible one.

At a metaphorical level, Shakti is not just the physical world that we see around us. Shakti is also our mind. Our mind is, by nature, wild and unfettered, but over time, we domesticate it with values and rules in our desire for a better life. The mind, in sacred literature, is distinguished from the soul because the mind is restless while the soul is restful. The mind can dominate and be affectionate; it seeks domination or affection. The soul witnesses the domination and the affection.

The cosmic demon killed by the cosmic Durga in Image 5.7 is the local demon killed by the local village goddess in Image 5.3. It is the demon who forgets who Durga is, who Shakti is. He is the observer-mind who forgets that she provides for him like a mother and a bride, and seeks to control her as a slave. Some have identified this demon as the ego, which craves power, domination and validation, and is greedy for attention and glory. Others say this demon is the monster of forgetfulness, who makes us forget the true nature of the Goddess.

In many parts of India, the demon who is destroyed by the Goddess transforms into her guardian, her Bhairava. In the story of Vaishno-devi, who is visualised in human form in Image 5.8 and as three rocks in Image 5.9, she tries to escape the lustful advances of a male ascetic. When the ascetic keeps pursuing her, she turns around in exasperation, transforms into a fearsome

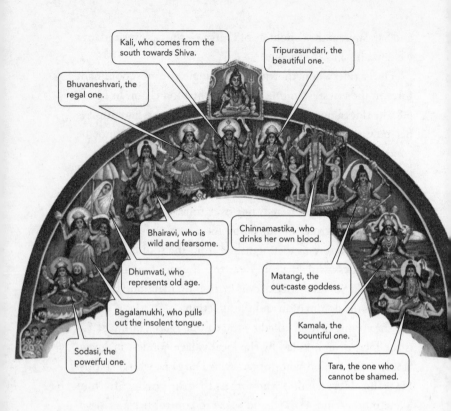

Image 5.10
The Mahavidyas, a collective of female deities who,
together, represent the Goddess

warrior and beheads him. Her tormentor repents and turns into her devotee and guardian; his shrine, not far from hers, is visited by devotees who visit her. Thus, he who seeks to dominate the Goddess can surrender to her. In other words, the one who chases desires can also submit to destiny.

Image 5.8 also shows the Goddess protected by the monkey-god, Hanuman. The story goes that when Vishnu descended on earth as Ram, the Goddess followed him, taking the form of Sita. During her stay there, she was abducted by a demon-king called Ravan. Hanuman helped Ram rescue Sita. But he did it selflessly. Never once did he look upon her with eyes of desire. He remained celibate all his life. In other words, he desired nothing. This restraint shown by a monkey made Hanuman worthy of worship. Not only did he become guardian of the Goddess, he became a deity in his own right.

The theme of transformation is thus repeated over and over again in Hindu mythology. Nothing is absolute. The forest transforms into a field and back into a forest again. The bride becomes a warrior, the killer becomes a mother, the tormentor becomes a guardian, the animal becomes god. Image 5.10 shows the panel of many goddesses that is around the head of the Goddess in Image 5.7. Some are wild, some are gentle, some are loving, some are horrific. Each one is an aspect of the Goddess. These are the Mahavidyas, or embodiments of great wisdom. Wisdom is acknowledging that nature is myriad and that matter can take many forms, not all of which appeal to our sense of morality and aesthetics. The Goddess is at once the wealth-bestowing Lakshmi in 5.4, the fearsome and fanged Bhagavati in Image 5.5 as well as the lovable Kamakshi in Image 5.6. Thus, wealth creates power, power can become love, domination can

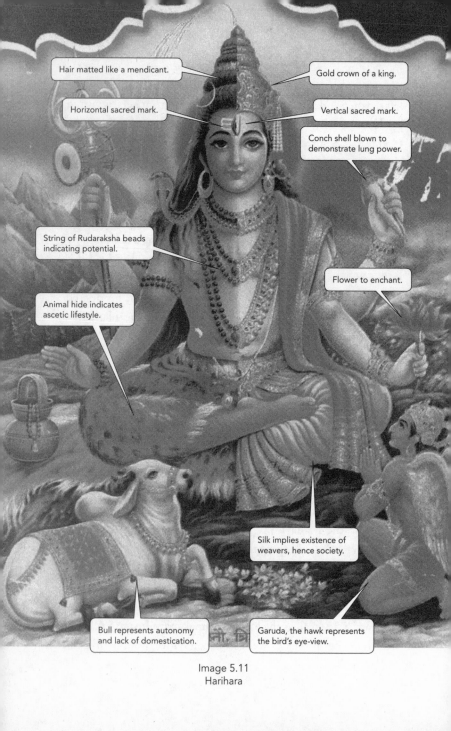

Hair matted like a mendicant.

Gold crown of a king.

Horizontal sacred mark.

Vertical sacred mark.

Conch shell blown to demonstrate lung power.

String of Rudaraksha beads indicating potential.

Flower to enchant.

Animal hide indicates ascetic lifestyle.

Silk implies existence of weavers, hence society.

Bull represents autonomy and lack of domestication.

Garuda, the hawk represents the bird's eye-view.

Image 5.11
Harihara

turn to affection, violence can give way to pleasure.

And while she transforms, the Goddess stimulates transformation. The creator can turn into the violator. The violator can be transformed into the defender. He who harms can become he who protects. He who desires can also show restraint. The indifferent one can engage. Sometimes one can be Shiva, comfortable with the way things are, and sometimes one can be Vishnu, determined to change things for the better.

Shiva is called Hara and Vishnu is called Hari. Image 5.11 shows Hari-Hara — the merged form of Shiva and Vishnu. These are the observers of life. Shiva is ash-smeared and destiny-accepting. Vishnu is anointed with sandal paste and desire-celebrating. Shiva wears strings of seeds and drapes himself with animal hide, while Vishnu wears flowers, gold and silk. Shiva's form implies the absence of society. He accepts life as it is without attempting to control or change it. Vishnu's form implies the existence of a society and a code of culture. He turns the forest into a field and a garden. The Goddess is that world around us — the one who stimulates us and the one we respond to as Hari or Hara. She makes us desire, she enforces destiny.

6
VISHNU'S SECRET
Detached engagement brings order

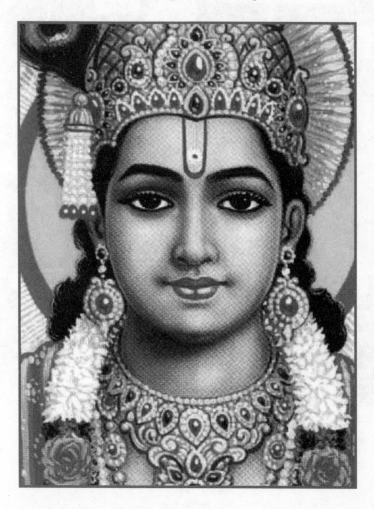

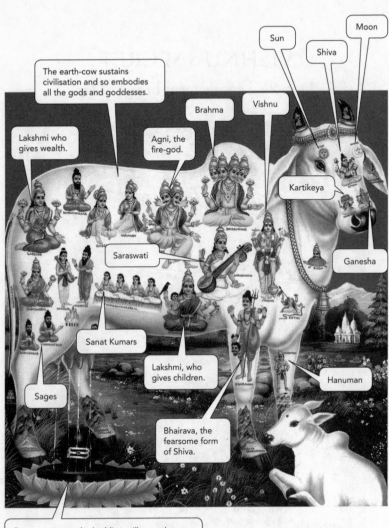

Image 6.1
Go-mata, the earth-cow

Image 6.1 shows a cow, the most sacred animal in the Hindu faith. To kill a cow is the greatest sin a Hindu can commit, and eating beef is the greatest taboo. Cows are gentle creatures. They ask for nothing, but they give milk to man, which can be used to make curd, butter, whey and sweets. Their dung becomes manure for the field, fuel for the kitchen and plaster for the floor and walls of the house. When they die, their skin can be used to make accessories, and their bones can be used to make tools such as combs and buttons. Thus, it plays a critical role in satisfying man's need for food, clothing and shelter. Naturally, cows came to have great economic significance. With a cow, a household could be sustained. The gift of a cow was a gift of life. Go-daan, or cow-charity, was the greatest charity. It satisfied all worldly needs. Hindus believe that even the gods who live above the sky have a magical cow called Kamadhenu, who can fulfil any wish, and from whom all cows descend.

Someone wondered: for whom does the cow produce milk — for her calf or for humans? How much milk can be taken by humans and how much should be left for the calf? All these questions expanded in scope and drew attention to man's relationship with the earth. Why did the earth exist? For all animals, or was it just for humans? We alone, of all living creatures, have destroyed ecosystems for our own survival — we transformed forests into fields for our crops and pasturelands for our cows, we established farms and redirected rivers to our settlements, we broke mountains as we searched for metals and gems, we pierced the earth in search of water. And the earth bore it all silently like the cow. So emerged the notion of Go-mata, the earth-cow, sustainer of all creatures, the great container of life as depicted in Image 6.1.

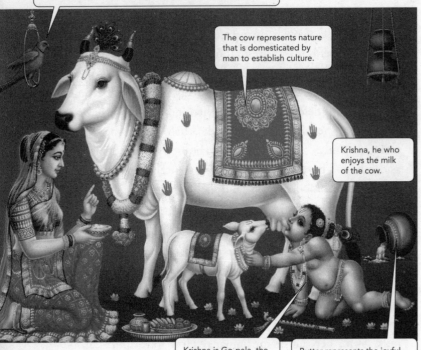

Image 6.2
Krishna with cow

In the *Bhagavata Purana,* the earth explicitly takes the form of a cow and runs away when she feels she is being exploited by man. Vishnu begs her to forgive man, which she does, on the condition that man treat her with respect in the future. Vishnu promises that man will do so and takes on the role of her protector. He becomes Go-pala, the caretaker of the earth-cow. That is why Vishnu is called the preserver and the sustainer. As shown in Image 6.2, Vishnu also enjoys the milk. He celebrates the bounty that nature bestows on man.

Through this story of Vishnu, there is an acknowledgement that human society is an artificial construct, an unnatural phenomenon constructed by domesticating nature. The Vishnu principle ensures there is harmony between nature and culture. Society cannot exist at the cost of nature, for when nature is destroyed, nothing survives. But in nature, might is right, the strong dominate the weak — it is society and social rules that reverse this trend, making room for the helpless and meek. The more one is able to move away from the law of the jungle, the more dharma is upheld.

The cow is not just nature (external material reality); it is also the mind (internal material reality). We want to be lions and dominate the world around us. But society forces us to be cows, to create value by producing milk, and giving that milk not just to our calf but to others as well. Society does not want us to be bulls like Shiva; society castrates the bull and turns the bull into an ox with its rules and regulations so that we are fit to pull the cart burdened with demands and duties.

Vishnu is Narayan in the woken state. Image 6.3 shows him as visualised in a temple in south India. This image has to be contrasted with Image 4.1 of Shiva. Shiva is associated with

The vertical mark of Vishnu indicates action and growth unlike the horizontal mark of Shiva.

Vishnu's crown indicates the existence of civilisation which appreciates beauty and wealth and makes room for miners and metal smiths.

The discus represents order and rhythm and predictability.

The conch-shell indicates the willingness of God to communicate with man.

The lotus represents the joys of worldly life.

Vishnu's garland of forest flowers is called vaijayanti, and since they whither every day, they demand daily attention and maintenance, making them symbols of routine responsibilities.

Vishnu's garland of flowers represents fulfilment and requires regular maintenance, unlike Shiva's garland of seeds which represents potential.

Vishnu wears yellow silk, indicating the existence of civilisation which makes room for farmers and weavers.

The mace represents the code of dharma, which is basically rejection of the law of the jungle that must be respected by man.

Image 6.3
Krishna at Guruvayur, Kerala

frozen water, snow; Vishnu is associated with the container of all water, the sea. The coiled, hooded serpent rests around Shiva's neck; Vishnu stands on top of a similarly coiled, hooded serpent. Shiva is smeared with ash, created by burning wood; Vishnu is smeared with sandal paste, created by soaking fragrant wood in water and rubbing it against a stone. Shiva wears animal hide; Vishnu wears finely-woven silk. Shiva wears a necklace of seeds; Vishnu wears a garland of flowers and is adorned with gems and gold. Shiva's sacred mark is horizontal implying inertia; Vishnu's sacred mark is vertical, implying activity. Shiva sits still, with eyes shut and a serene face; Vishnu's eyes are open, he smiles, and he is ready to step into the world.

Vishnu holds four tools in his hand — a conch-shell that announces his presence; a discus that reminds us that life is constantly moving and all things that go around come around; a mace with which he strikes down those who break his law; and a lotus whose colour, fragrance and sweet nectar are reward for those who uphold the law. Vishnu's law is born of a value system called dharma. Dharma is that which creates a stable society. On the one hand, it domesticates nature and tames the animal within man. On the other hand, it does not allow for the destruction of nature and is sensitive to the primal needs of man.

Image 6.4 shows Vishnu with Lakshmi seated on the coiled serpent called Sesha while 6.5 shows Vishnu and Lakshmi flying on a hawk called Garuda. Lakshmi is the Goddess of wealth and power. She is the container of fortune. Vishnu never comes to her; she always goes to him. She is with him when he is still (represented by the hooded serpent) and when he is on the move (represented by the flying hawk). In other words, a stable and organised society generates wealth. Vishnu is the

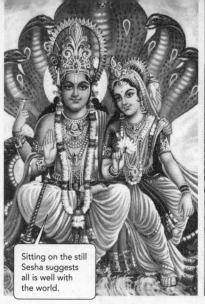

Image 6.4
On the coils of Sesha

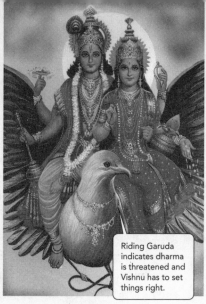

Image 6.5
On the wings of Garuda

Image 6.6
Lakshmi with Alakshmi

farmer, Lakshmi is the field. Vishnu is the leader, Lakshmi is his organisation. One cannot exist without the other.

Image 6.6 also shows an owl sitting by the Goddess' feet. This owl is said to be Lakshmi's sister, Alakshmi, the goddess of strife. When Lakshmi is worshipped, Alakshmi, her elder sister, is always acknowledged, so that we never forget that with money come quarrels and fights — and we are prepared for it.

Lakshmi follows Vishnu because Vishnu institutes and maintains dharma by overturning the law of the jungle. The jungle is based on the law of domination — the point is to survive, either through strength or cunning. But society is supposed to be based on the law of affection — where people care for and take care of each other. In the jungle, animals think only about themselves, their offspring or their herd, but in society, humans have the capacity to think beyond themselves and care for all humanity and even for animals, plants and minerals.

As time passes, all societies change, values change, society which begins in perfection moves towards imperfection, then collapses, and then is resurrected in perfection. Vishnu's discus is a reminder of the cyclical nature of things. The conch-shell shows the unravelling of time. Air that passes through the conch-shell gradually expands, creating sound, and then returns to primal silence. Thus there is a rhythm in the world.

The material world is changing, but with Vishnu, the change becomes cyclical, rhythmic, predictable. Vishnu thus manages the changes of time — he does not stop it. Shiva may shut his eyes to the Goddess, but Vishnu's eyes are wide open and he smiles, for he understands the dance of matter and dances with her.

Vishnu is called the lord of maya. Maya essentially means

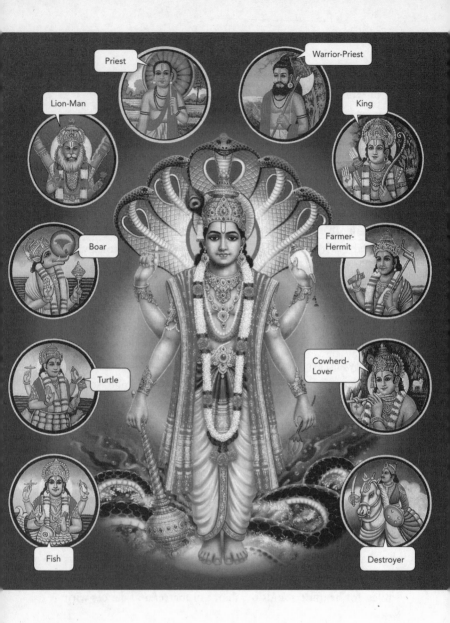

Image 6.7
The ten incarnations of Vishnu

'measurement'. We constantly measure material reality and make judgements: is it right or is it wrong? Is it good or is it bad? Is it expensive or is it cheap? The answer depends on the measurement scale. Vishnu is the source of all measurement scales — hence, he decides what is beautiful and what is not, what is appropriate and what is not. All that is true and auspicious and beautiful according to his scale, he accepts — the rest is rejected. Vishnu's scale is based on one principle — love, caring, affection for the other. In other words, Vishnu turns away from the spontaneous law of the jungle based on domination and power. Vishnu also knows that all measurements are manmade and can change over time. Hence, all rules are flexible. That is why he knows culture and civilisation are like a game, leela — fun if everyone upholds the rules and enjoys the participation. Games turn ugly when the rules are twisted and turned in our obsession to win. When winning is all that matters, then we turn into demons, Asuras and Rakshasas, who celebrate the law of the jungle.

Vishnu institutes and maintains dharma, and adapts the laws according to the demands of history and geography by descending on earth as an avatar. Image 6.7 shows all the avatars.

The first of these avatars, Image 6.8, is a fish or Matsya. In this avatar, Manu, the first man, saves the small fish from the big fish by taking him out of the sea and placing him in a pot. This act of compassion creates society. The pot is the symbol of human society, and is seen in the arms of Lakshmi in Image 6.6. Later, the fish grows in size and keeps growing; Manu transfers the fish from the pot to a larger pot, then a pond, then a lake, a river, and finally, a sea. The fish keeps growing until rains fall to make the sea large enough for the growing fish. So much rain falls that

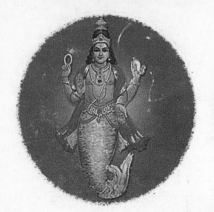

Image 6.8
Matsya Avatar

Image 6.9
Kurma Avatar

Image 6.10
Varaha Avatar

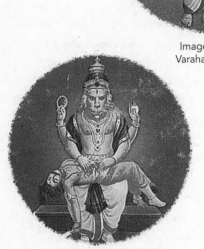

Image 6.11
Narasimha Avatar

Image 6.12
Vaman Avatar

the earth gets submerged and Manu, once the saviour of the fish, finds his world getting destroyed. Why is this happening? Because the fish kept growing in size and Manu kept helping it, never realising that it was time to stop, time to let the fish go and fend for itself. Thus, civilisation starts when compassion begins. Civilisation collapses when there is too much kindness and one doesn't know when to stop, when to draw the line. The fish ultimately saves Manu and teaches him this valuable lesson of human society.

Vishnu then takes the form of a turtle or Kurma, Image 6.9. He holds on his back a spindle that the Devas and Asuras use to churn the ocean of milk and draw out Lakshmi. Vishnu then takes the form of a woman, an enchantress called Mohini, and seduces the Asuras, distracting them so that all the treasures that emerge from the ocean go to the Devas. The furious Asuras become the eternal enemies of the Devas. They drag the earth under the sea, which Vishnu brings back as a boar or Varaha, seen in Image 6.10.

With amrita, the nectar of immortality, obtained from the ocean of milk, the Devas become immortal. Asuras yearn for amrita. They demand various kinds of boons from Brahma, the creator, but each time Vishnu thwarts their attempts. Image 6.11 shows Vishnu killing an Asura who tried to make himself invulnerable by asking for a boon that he should not be killed by either a man or a beast. Vishnu attacked him in the form of a creature he had not conceived, one who was neither man nor beast, or perhaps both a man and beast. This story has been elaborated in Chapter 2 (Narayan's Secret) where the violent and gentle forms of Narasimha are depicted in Images 2.8 and 2.9.

Asuras who live under the earth get Sanjivani Vidya from

Image 6.13
Parashurama Avatar

Image 6.14
Ram Avatar

Image 6.15
Balaram Avatar

Image 6.16
Krishna Avatar

Image 6.17
Kalki Avatar

Shiva, which enables them to resurrect the dead. This makes them equal to the Devas, who are immortal thanks to the amrita. Vishnu then takes the form of a Brahmin boy or Vaman, Image 6.12, and shoves the Asuras under the earth, claiming the earth and the sky for the Devas. Thus, though both are equally powerful, Vishnu gives them different spheres of influence. Asuras are below the earth regenerating the wealth of the earth — minerals and plants — while Devas are above, pulling out minerals and crops for the benefit of humankind. Thus their conflict creates wealth. They are the force and counterforce of the cosmos, spinning the world around, churning it, thanks to Vishnu. Thus tension and hierarchy are essential ingredients of the organisation called civilisation, established through dharma by Vishnu.

In Image 6.13, Vishnu abandons the Brahmin form, takes up an axe and becomes a warrior, striking down kings who use their position to exploit rather than serve society. This is Parashurama, Rama with an axe, who rose up when kings of the earth used their might to plunder the earth's resources. Parashurama kills a king who steals his father's cow. He even kills his own mother because she is attracted to a man other than his father. This story introduces us to the dangerous power of sexual desire and material desire. If not checked by rules of marriage and property, they can destroy civilisation.

Image 6.14 introduces us to Vishnu as Ram, the ideal king, the one who sacrificed personal pleasure to uphold dharma. Image 6.15 and Image 6.16 are of two brothers, Vishnu as Balarama and Vishnu as Krishna. The former steps away from the world and renounces all rules. The latter participates in the world and keeps bending the rules. Balarama is often equated

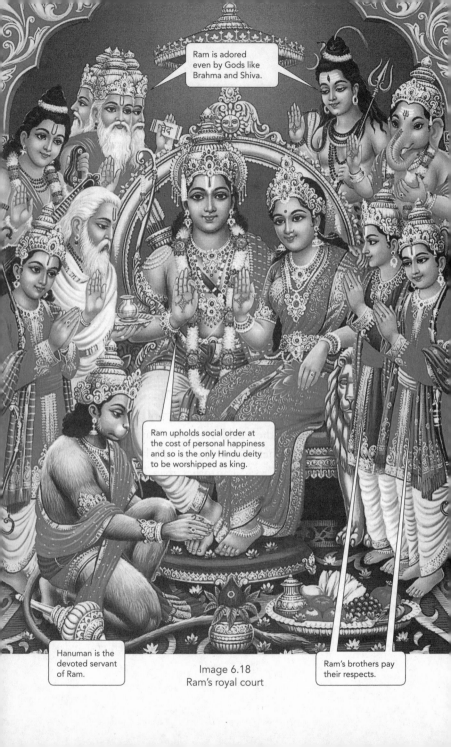

Image 6.18
Ram's royal court

with Buddha in many poster arts — they follow the hermit's ideal, much like Shiva, of stepping away from society because they are either fed up of the stranglehold of rules or have realised the artificial nature of rules that results in conflict and suffering. Ram and Krishna, on the other hand, engage with the world, Ram by upholding rules and Krishna by changing rules, both for the sake of dharma. Image 6.17 introduces us to Kalki, the last of Vishnu's avatars, the one who rides a horse and wields a sword, the one who will destroy the society that has become totally corrupt, no different from the jungle so that the cycle of avatars will restart from the fish of Image 6.8.

Of all the avatars, Ram in Image 6.18 is the most revered, the only form of God to be worshipped as king. Kingship or leadership is perhaps the most difficult role in society. It is the king who leads the move from nature to culture, from the law of the jungle to the code of culture, from mastya nyaya (law of fishes) to dharma (law of humans). It is he who determines the yardstick of appropriate conduct in human society. It is he alone who has the power to decide who is right and who is wrong, who is good and who is bad, who should live and who should die. The Goddess sits on his lap as a demure wife. In his arms, she is safe and comfortable. The monkey Hanuman sits at his feet, indicating that he tames all animal instincts of domination through power or cunning. He is blessed by the various forms of God. Around him are his brothers who serve him.

The story of Ram, told in the epic *Ramayana,* is the story of brothers working towards creating a society full of caring. This society is shattered when Ram's ambitious stepmother asks his father to send Ram into forest exile for fourteen years and make her son king instead. Ram goes into the forest in

Image 6.19
Sita's abduction

deference to his father's wishes, but Ram's brother, in defiance of his mother's wishes, refuses to take the throne obtained by deceit. He waits for his elder brother to return and reclaim his rightful inheritance. In the forest, Ram's wife, Sita, is abducted (Image 6.19) by Ravan, a Rakshasa, who became king of the island of Lanka by driving away his brother, Kubera, the king of the Yakshas. Ravan, though raised as a Brahmin, behaves like an animal — taking other people's property and other men's wives by force. Ravan believes in power and not in law. Ram is the very opposite. He rescues Sita by raising an army of animals (monkeys, bears and vultures) who are transformed after contact with him into creatures more noble than human beings. They fight for Ram, for a cause that is not theirs, a trait that only humans are capable of displaying if they wish to.

Ram is born at an earlier age, when men like Ravan did not believe in a code of civilised conduct. Krishna is born at a later age, when men like Kamsa and Duryodhana subvert the code of civilised conduct so that law is upheld only in letter, not in spirit. Image 6.20 shows various events in the life of Vishnu when he walked the earth as Krishna. These tales form part of the narrative known as *Bhagavata Purana*. They explore the most delightful of human emotions and introduce us to the concept of passionate devotion. If Ram is about laws and appropriate conduct, Krishna is about love and affection. While Ram focuses on discipline and the head, Krishna focuses more on affection and the heart.

Ram is king, but Krishna is not a king. As a child, to protect him from the tyranny of his maternal uncle, Krishna had to be whisked away to a village of cowherds and raised as one. Image 6.2 shows Krishna as a toddler with Yashoda. Yashoda is his

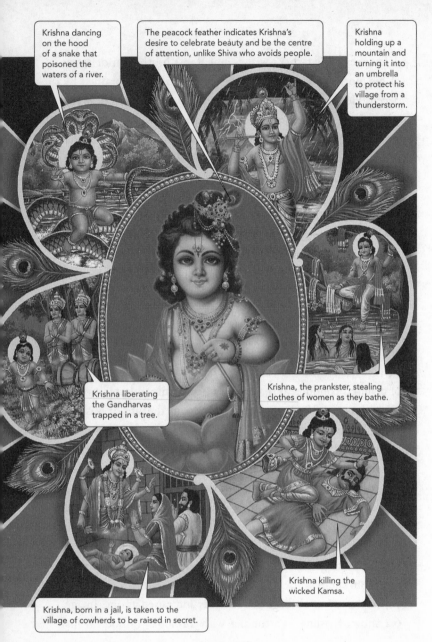

Image 6.20
Krishna's childhood

foster mother, not his biological mother — but that does not change the love they have for each other. Thus bonds are not created by blood alone. This image can be viewed in two ways. It shows how man should approach the earth, as a child to the mother. It also shows how man should approach his soul, as a mother to a child. Thus the highway of emotion is created to connect with material as well as spiritual reality.

In Image 6.21, the soul becomes the beloved to be adored by the lover — the mind. This image introduces us to the great divide in Hindu metaphysics. It shows Krishna with his beloved milkmaid, Radha. The idea of Radha became popular thanks to the *Gita Govinda,* a Sanskrit work by a poet Jayadeva, written in the 12th century, which describes in intimate detail the dalliances of Krishna and his beloved. Before this work, Krishna was associated with many milkmaids, not one in particular. By introducing Radha into the mythic landscape of Krishna, the poets and sages of India expressed an understanding of divinity that was acceptable to some, but not to others.

When the Vedas revealed the mysteries of divinity, scholars called this revelation Vedanta, the acme of Vedic wisdom. For some, Vedanta revealed that all humans can discover the divine within them and joy comes when perfect and absolute realisation, free of all prejudices, is attained. This oneness with God was called Advaita. For others, Vedanta revealed that God and man are separate and joy comes by surrendering to the Almighty. This was Dvaita or dualism. In Advaita traditions, the devotees are the milkmaids who do not realise that they are one with the supreme cowherd, Krishna. So they dance around him until realisation strikes and all divisions collapse. In Dvaita traditions, the devotees are servants of Krishna and Radha, the

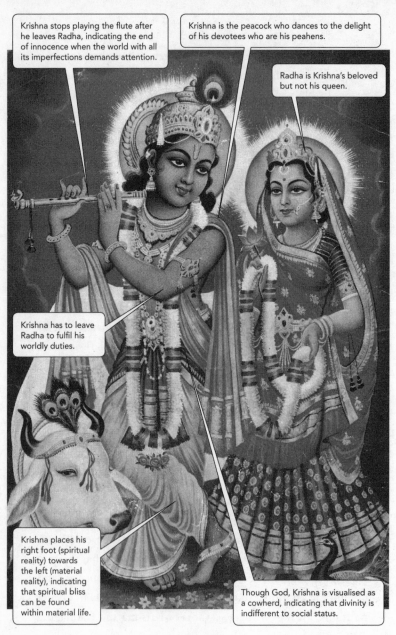

Image 6.21
Krishna with Radha

divine couple, Purusha and Prakriti, eternally in embrace. In Advaita traditions, Krishna ultimately disappears. They hear only his flute. This is the dissolution of God with form and the emergence of God without form. In Dvaita traditions, Krishna and Radha live forever in the eternal bower called Go-loka, the highest heaven. All devotees seek to reach this delightful paradise eventually and serve the divine couple.

In the scriptures, Krishna does not stay in the village of cowherds. Ultimately, he has to say goodbye to his Radha, leave Madhuvan, the garden of delight, and return to Mathura, the city of his father, to kill his wicked uncle, Kamsa, who terrorises the city. In retribution, Kamsa's father-in-law, Jarasandha, burns down the city of Mathura, forcing Krishna and the residents of Mathura, the Yadavas, to move out and make a new home far away in the island of Dwarka. Krishna marries many women, mostly princesses. One of them is Rukmini who stands next to him in Image 6.22.

Thus the Krishna of Image 6.21 with Radha is very different from the Krishna of Image 6.22 with Rukmini. The former is a lover, the latter is a husband. The former plays a flute, while the latter blows a conch-shell. The former lives in a village where he grazes cows, makes music and dances with milkmaids, while the latter lives in a city where he shoulders responsibility as a father and as a statesman. The former Krishna's tale is found in the *Bhagavata Purana* where the theme is love. The latter Krishna's tale is found in the *Mahabharata* where the theme is power.

Around Image 6.22 revolves the story of Dnyaneshwar, a saint from the state of Maharashtra, where the image of Krishna (locally known as Panduranga) is worshipped along with Rukmini (locally known as Rakhumai). Dnyaneshwar's father

Image 6.22
Dnyaneshwar, the saint of Vithal-Panduranga

became an ascetic but returned to his wife when his spiritual master turned him back on the grounds that one should not walk away from worldly responsibilities. Since he returned to the householder way of being after taking his vows as a hermit, Dnyaneshwar's father was condemned by the village elders. They excommunicated him, his wife and his four children. After many appeals, the village agreed to let the four children return, provided the parents apologised for their transgression by killing themselves. For the sake of their children, Dnyaneshwar's parents killed themselves, but the village still refused to let the orphans in. As outcastes, the orphans were left to fend for themselves. They lived with hermits, and it is these interactions with hermits that transformed Dnyaneshwar into a great saint. He became a Siddha, i.e., by being a celibate sage with full control over his senses, he came to possess magical powers — he could generate enough heat for his sister to cook food on his body; he could make a buffalo sing Vedic hymns; and he could make a wall fly to meet another Siddha who came to visit him on a tiger.

Siddhas were also known as Naths or Masters. These were experts in the occult arts, men who wandered the countryside and could perform miraculous feats. They were rarely members of society. They were hermits — not just sages but also sorcerers, feared and revered for their potent powers.

Image 6.23 introduces us to the nine greatest Siddhas or the Nav-Naths who had a profound influence on Dnyaneshwar and his brother. These Nav-Naths revered Adi-nath, Image 6.24, the primal master, who was considered to be both Shiva and Vishnu.

Shiva and Vishnu embody two opposing views. Shiva indicates a Tantrik approach to life, while Vishnu, a more Vedic one. Shiva treats material reality as shakti or power, to

Gahininath

Revananath

Nageshnath

Bharatnath

Charpadinath

Kanifnath

Matsyendranath, who heard the secret conversation between Shiva and Shakti in a former life as a fish.

Jalindarnath

Gorakhnath, who rescued his teacher Matsyendranath from the enchanted land of women.

Image 6.23
Nav-Nath, the nine masters

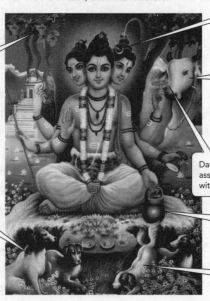

The banyan tree indicates that Dattatreya is a mendicant more interested in spiritual reality than material reality.

Dattatreya's moon associates him with Shiva.

Some say that Dattatreya is associated with the Vedic cow while others say it is the Tantrik bull.

Dattatreya's disc associates him with Vishnu.

Dogs are considered inauspicious in orthodox Hinduism but are sacred to Tantrik hermits.

Dattatreya's pot associates him with Brahma.

The four dogs represent the four Vedas.

Image 6.24
Dattatreya, the Adi-Nath or primal master

be manipulated with powers developed through celibacy and sensory control, which in turn are developed through sensory manipulation and creative visualisation. Vishnu embraces material reality. Recognising it as a temptation or maya, he disciplines the mind with asceticism so that the mind is not swept away by it. Tantrik doctrines reject the code of dharma, unlike Vedic doctrines. Tantrik doctrines are not mainstream. They belong to hermits, men and women who have rejected the social code. Vishnu's doctrines are more social, more suitable for householders, for mainstream members of society. Tantrik doctrine is associated with intense sensory engagement and involves the use of bright colours, narcotics, meat and sex. Vedic doctrine is associated more with meditation, silence and quiet contemplation. Yoga is the balance of the two doctrines.

Of the Nav-Naths or nine masters who were popular in medieval India, the two most famous were the leader Matsyendranath, and his disciple Gorakhnath. Matsyendranath's name has its roots in Matsya or fish, and Gorakhnath's name has its roots in Gorakh or cow-saviour, suggesting that Matsyendranath was more associated with the Tantrik side of the doctrine (fish being a metaphor for jungle law, wild sex, restless material reality as well as non-vegetarian food), while Gorakhnath was more associated with the Vedic side of the doctrine (cow being a metaphor for cultural law, domesticated sex, tamed material reality and vegetarian food). Both considered Adinath or Dattatreya as their master. Matsyendranath was, however, more sympathetic towards hermits and occultists, while Gorakhnath was more sympathetic towards house-holders. Dnyaneshwar was more influenced by Gorakhnath, while his elder brother was more influenced by Matsyendranath.

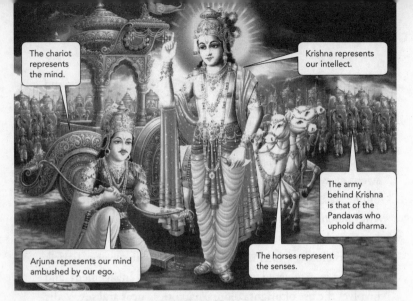

Image 6.25
Arjun hearing Krishna sing the *Gita*

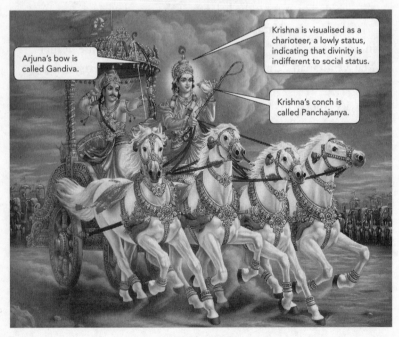

Image 6.26
Arjun riding into battle with Krishna

That is why Dynaneshwar is remembered not for his magical powers but for translating the *Bhagavad Gita,* the song of Krishna, into the language of the local people. This song helped people stay spiritual while living a material life.

Image 6.25 shows Krishna singing his song, the song of God. The event is described in the epic, the *Mahabharata,* which describes the feud between cousins over property. Krishna's brother, Balarama, refuses to participate in this war over land. Krishna, however, serves as a charioteer, guiding Arjuna to victory. But just before the war is about to start, Arjuna loses his nerve, saying he does not see the point of fighting a war that would involve killing family and friends, for land. The *Bhagavad Gita* is an encapsulation of what Krishna tells him. It is a discourse on how to engage with the material world. Krishna clarifies that the world is transitory, that everything changes. The world changes and the flesh dies. But the immortal soul survives. The purpose of life is to realise this soul. And the only way to do that is to live life. The more man loses touch with the soul, the less he behaves like a human — he behaves like an animal, seeking power and domination, as Arjuna's cousins, the Kauravas, do. If man has to regain knowledge of the soul, he has to stop behaving like an animal. He must destroy that desire to dominate the world — in other words, he must destroy the Kauravas. Only when the Kauravas are destroyed, not in rage or in revenge, but out of a sense of responsibility for the good of society at large, will the soul be realised. The point is to control one's senses and one's mind, do one's duty with detachment, to focus on action not result and to have faith in the soul.

The point of the *Bhagavad Gita* is not to kill the Kauravas, but to kill that urge that creates conflict. Conflict comes when

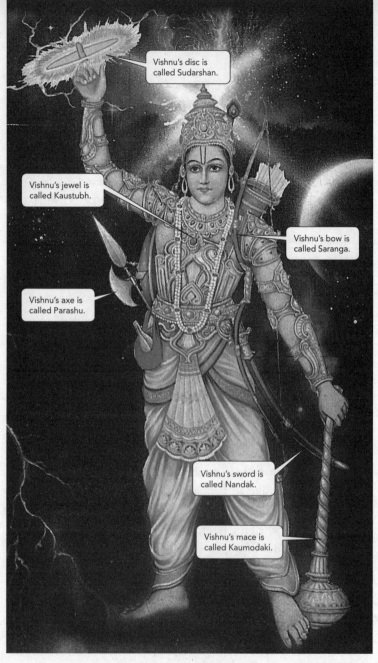

Image 6.27
Vishnu-Krishna with his weapons

man functions for power rather than out of love. Arjuna does not want to fight not because he cares for the world; he does not want to fight because he fears his enemy and his own image of himself. Krishna forces Arjuna to realise the true nature of the world — the soul and matter. He shows Arjuna how society is constructed by laws and how laws are created to create a world where the mighty support the meek. If laws are misused to abuse and exploit the weak, then the law of the jungle prevails. This is adharma, and if man loves humanity, he must rise against adharma. He must fight to establish dharma.

That is what Vishnu does. He descends from time to time, upholding dharma, overturning the law of the jungle. Unlike Shiva, he will not shut his eyes to the Goddess. He will open his eyes, he will recognise her transformation and, with a smile, he will play with her. Image 6.27 shows Vishnu-Krishna holding weapons. These are his tools with which he creates order and predictability. He will institute, maintain and redefine dharma so that in every age, it brings peace, stability and prosperity to all.

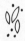

7
BRAHMA'S SECRET
Human life is an opportunity

Image 7.1
From the navel of Vishnu

So much has been said about Shiva and Vishnu and about the three Goddesses, but what about Brahma? An occasional image here and there, Image 7.1 for example, usually with the other gods, but nothing else. No festival, no ritual, no prayer for Brahma. Why so?

To understand this we have to ask ourselves two questions: Why do we want the creator to be so acknowledged? Why is the creator in Hindu mythology not given the same status as the preserver or the destroyer?

When the word 'creator' is uttered, we take the Bible as the reference point and assume that since God is the creator there, it must be so in the Hindu world as well. But in the Hindu world, creation happens for a reason and Brahma forgets that reason, which is why he is declared unworthy of worship.

In the Vedas, the poets wonder why the world exists. After much deliberation, they conclude that it exists to help us know ourselves. The idea was elaborated in the Upanishads, where it is said that to understand the self, the primeval being known as Purusha, the self must be split in two, thereby creating 'the other'. Thus, 'the other' exists to understand 'the self'. In the Puranas, this abstract idea is expressed through the tale of Brahma. While reading his story, one must keep in mind Ardhanari's Secret (Chapter 3) that the god and the goddess are embodiments of gender-neutral ideas, that the male form (Brahma) represents the self, the observer, the spiritual divine within, while the female form (Shatarupa) represents the other, the observation, the material divine without.

Brahma created the world to understand who he was. The world was a woman, his creation, hence his daughter. Rather than learn from her, Brahma became enchanted by his own

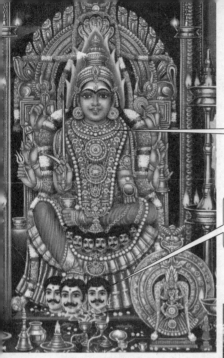

The Goddess strikes down those who seek to control her.

Virile heads with moustaches are indicative of the egos that seek to dominate material reality.

Image 7.2
Devi, the Goddess

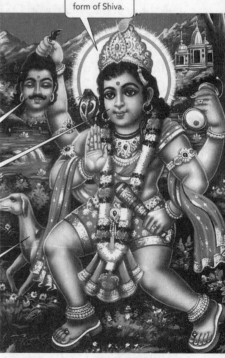

Bhairava is a form of Shiva.

The virile head with a moustache is a symbol of the male ego.

The boyish look of Bhairava indicates his innocence and purity.

The dog indicates that Bhairava is an out-caste.

Image 7.3
Bhairava, the fearsome guardian of the Goddess

daughter. When she circumambulated him in order to pay her respects to her father, he popped four heads so that he could see her wherever she was. Then, she turned into a cow; Brahma instantly turned into a bull. When she turned into a goose, he became a gander. In other words, he lost all sense of himself. He became so obsessed with controlling her, conquering her, that he kept turning into the male counterpart of her female form. Little did he realise that she was material reality, forever restless; she was Shatarupa, she of myriad forms. She was matter, Prakriti. She was energy, Shakti. She was the great delusion of life — Maya.

How can anyone worship one such as Brahma — one who is still chasing the material world rather than trying to understand himself? Who is this Brahma? Is he you, the reader? Is he me, the writer? Is he the one who is trying to control his life, the demon who has been crushed underfoot by the Goddess in Image 7.2? This is never stated explicitly.

What is stated explicitly is that Shiva cuts the fifth head of Brahma and uses his skull as a drinking bowl. Shiva thus becomes Kapalika, the skull bearer. Shiva is Bhairava, who opposes Brahma's lustful intent. He is innocent as a baby, Image 7.1. He is innocent as a pre-pubescent boy, depicted in Image 7.3. He is Bhairava, the fearsome guardian of the Goddess. In his hand is Brahma's fifth head. The fifth head indicates the ego — that part of the mind that seeks control over material reality. Shiva is everything Brahma is not. Shiva destroys what Brahma creates. Brahma creates Kama, lust; Brahma creates Yama, death; Brahma creates karma that rotates the cycle of rebirth; Brahma creates the ego; Brahma creates the three worlds — the private, the public and all the rest there is. All this makes him

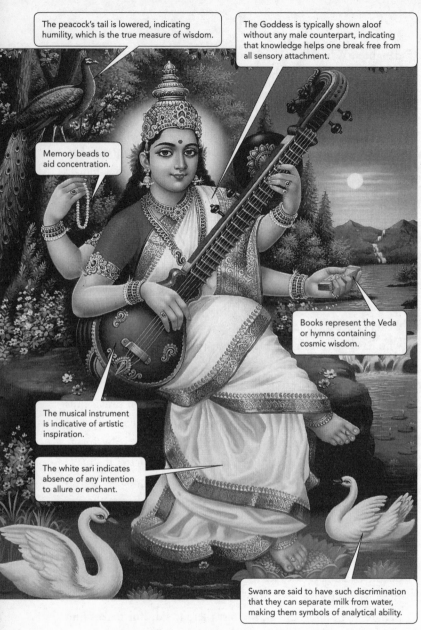

Image 7.4
Saraswati, the Goddess of knowledge

unworthy of worship.

The purpose of life is to realise the ego and overpower it — either destroy it as Shiva does or be detached from it as Vishnu is. This can only happen when we learn from life. Until man realises this, he goes through several lifetimes. That is why Brahma's consort is Saraswati, the simple goddess of learning shown in Image 7.4. Dressed in white, with book and lute in hand, this goddess does not nourish the flesh and does not stir emotions. Lakshmi's presence may make a man rich and powerful, Durga's presence may fill a man with fear or love, but Saraswati's presence brings serenity. She is the knowledge of the world, all the information there is, which when used can eventually become wisdom. Sometimes she is associated with a gander or a crane, but mostly with a swan. A swan or gander is believed to have the power of separating milk from water, making it the symbol of the mind's discriminating power. She is also associated with a peacock. But the peacock does not spread its feathers to show off its beauty, suggesting that a true understanding of any subject leads to humility, for the more you know, the more you realise how much more there is to learn; uncertainty will lead you to seek and discover more.

This makes human life special. As a human being, one is blessed with the ability to reflect on existence and think about its meaning. This reflection leads to self-discovery. Because humans are blessed with manas or mind which analyses and evaluates the world around, humans are called Manavas.

Hindus believe that one becomes Manava or human only after passing through eighty-four lakh wombs. As the soul journeys through many lifetimes, it adorns itself with various bodies at the time of birth and discards them at the time of

Image 7.5
Nava-Graha

death. Between life and death, the body acts. Each action has repercussions. The soul is obliged to experience the reactions generated by the actions of its body. This is karma. That is why karma determines all things over which we have no control: our bodies, our parents, the circumstances of our life.

But the human mind, ambushed by the fifth head of Brahma, does not realise that all events experienced by the body are its own creation. The ego has no memory of actions performed in past lives. It refuses to take responsibility as the creator of the world around him. In other words, Brahma, the divine within, refuses to accept that the world around, the Goddess, is his own daughter. So he chases her and seeks control over her. By controlling the world, he believes he will validate his existence. His attention then moves away from the soul within and anchors itself on the matter without. So the purpose of life then becomes material well-being and not spiritual well-being. All actions and rituals then are geared to changing the material world, to make it more pleasant, rather than training the mind to accept the material world for what it is and through it discover the spirit within.

Hindus believe that karma is manifested through nine celestial bodies, the Nava-Grahas, Image 7.5, who rule time. Though divine beings, the Grahas have no will of their own. They are compelled to influence our lives at a particular time for a particular period, depending on what is written in our fate.

In Vedic times, the Rishis came up with the *Jyotisha-Shastra*, the science of light, simply known as astrology, by which one can calculate the relative position of the Grahas in our life, depending on the time and place of our birth. This then reveals what fate has in store for us. Thus, we can be prepared for a

Image 7.6
Vastu-Purusha

calamity or hope for a fortune.

But what if the fate the *Jyotisha-Shastra* reveals is not something we like? The Rishis came up with the concept of Upaay, or way out. Using gems and certain chants and rituals, one can increase or decrease the influence of a particular Graha in our life. Thus we can influence the future. It is not just fate; there is free will.

Another way of influencing the effects of fate is by using the science of space or geomancy, known to Rishis as *Vast-Shastra*. The earth is naturally circular, aligned to the horizon, but man's dwelling is a square, circumscribed in that circle. This square of human settlement is Vastu Purusha, and this square can be broken into a smaller size. Each direction is governed by a god, a Digga-pala. By reorienting walls, windows and doors, it is possible to shift the energy of the gods such that it brings good fortune into the house. Thus, through desire, one can perform rites and change what destiny has in store for us.

Image 7.6 shows Vastu Purusha. Vastu Purusha was a demon who tried to rise from the earth and block the sky. The various gods pinned him down. Each god is the ruler of the point where he still holds down the demon. The north is ruled by Kubera, the treasurer of the gods; the south is ruled by Yama, the god of death; the east is ruled by Indra, the god of rain; the west is ruled by Varuna, the god of the sea; the north- east is ruled by Soma, the moon; the south-west is ruled by Surya, the sun; the north-west is ruled by Vayu, the wind; the south-east is ruled by Agni, fire. Opposite directions complement each other. Thus a balance is created in the cosmos. In the centre stands Brahma, the navel — man himself, the centre of his world.

Space and time are manipulated through *Vast-Shastra* and

Image 7.7
Naga

Jyotisha-Shastra to generate material wealth and to harness fortune, fertility and household prosperity. Rituals and prayers directed at the Grahas and the Digga-palas do not seek any spiritual goal like enlightenment.

Material wealth comes from the nether regions. Plants come from under the ground, minerals come from under the ground, water comes from under the ground. Hence, creatures who live under the ground are highly revered in Hinduism. Special importance is given to cobras, hooded-serpents known as Nagas, especially when they live in abandoned termite hills. These are considered to be gateways to the nether regions where hides the occult power of nature's fecundity. Nagas are said to live in a city called Bhogavati, which is made of gold and gems. They are supposed to have rolled on grass on which was kept amrita, the nectar of immortality. That is why they are able to slough their old skin and grow new skin — making them potent symbols of renewal and regeneration.

Some Nagas, such as the one in Image 7.7, are said to have a gem on their hoods. This gem, or the Naga-mani, has the power to fulfil any dream or give shape to any wish. Hence, everyone seeks this gem. Once again, the desire for the Naga-mani and the blessings of the Naga stems from the desire for fortune. Hindus are not content accepting that fate does not have fortune in store for them — by praying to the Naga, one hopes to usher in what fate has denied.

Image 7.8 introduces us to another class of beings known as Yakshas. While the Nagas live under the ground, the Yakshas live in the north near the Himalayas in the city of Alakapuri. Here, they hoard all kinds of treasures. While the Nagas are associated more with organic wealth like plants and children, the

Image 7.8
Kubera

Yakshas are associated more with metals and gems. Naga women and Yaksha women are supposed to be dangerously seductive. Yaksha men are typically fat, dwarfish and disfigured. Their king is called Kubera. The story goes that once Kubera had a city in the south called Lanka, but his brother, Ravana, leading another set of beings known as the Rakshasas, drove him away from the south to the north. Kubera is the treasurer of the gods. He has a pet mongoose which is the enemy of serpents, indicating an antagonistic relationship between the Nagas and the Yakshas. Nagas generate wealth, while Yakshas hoard it.

The *Jyotisha-Shastra*, *Vast-Shastra* and worship of Nagas and Yakshas are aimed at manipulating the forces of time and space to make fortune flow in a particular direction. Both these sciences assume that man can control his destiny and change his fate. But there are other rituals based on another force that governs the world — desire. It is desire which propelled Brahma to chase the Goddess in the first place. By his desire, he changed her shape. Thus, through desire, man can change the world. This desire for a better life manifests in many rituals called Vrats.

Image 7.9 depicts the Satya-Narayan-Vrat and Image 7.10 depicts the Santoshi-maa-Vrat. The Satya-Narayan-Vrat can be performed on any day but only by married couples, while the Santoshi-maa-Vrat can be performed only on Fridays by women. The former is aimed at bringing happiness, good luck and health into the household; the latter is performed by women seeking marriage, maternity and the end of misfortune. In the Satya-Narayan-Vrat, the intervention of a priest is required; this is not so in the Santoshi-maa-Vrat. Satya-Narayan is seen as a form of Vishnu, while Santoshi-maa is seen as a form of Shakti. Curiously, there is no mention of either deity in traditional scriptures such

Image 7.9
Satya-Narayan-Vrat

Narad narrating the stories explaining the value of the Vrat.

The happy household of the merchant who follows the Vrat.

Legal problems faced by the devotees when they forget Satya-Narayan.

Mother and daughter of suffering souls narrating the story of Satya-Narayan and observing his Vrat.

The pot topped with coconut is the universal symbol of the divine in Hinduism.

Image 7.10
Santoshi-maa-Vrat

The wife tortured by her sisters-in-law as she waits for her husband.

The husband separated from the wife as he seeks worldly fortune.

Children being fed after Santoshi-maa has been duly worshipped.

as Agamas, which refer to temple rituals. Both are household rituals performed by householders and housewives to resolve household issues. The Satya-Narayan-Vrat involves chanting the thousand names of Vishnu, each time offering him a sprig of tulsi. Through this repeated chant, the determination of the couple is expressed and God is invoked, pleased to fulfil the wishes of the determined couple. For the Santoshi-maa-Vrat, the woman eats only one meal every Friday, makes offerings of gram and jaggery to the deity and avoids all sour things. Through these special meal observances, the devotee's intention is expressed, causing the Goddess to change fate in her favour.

In both Vrats, stories are narrated. The stories tell of merchants who face misfortune when they abandon their respective deities and who regain fortune when they once again show due regard for the deity. These rituals are simple, aimed at invoking deities and expressing one's desire through choreographed observances such as fasting, changing, hearing tales, singing songs, staying awake through the night, visiting holy shrines and bathing in holy ponds and rivers. Seeking a boon and a blessing from a god, a God, a goddess or a Goddess is considered a good thing, and the best way to overturn the vagaries of fate.

The rituals of the common man in Hinduism clearly show a greater focus on the simple material pleasures of life. But the scriptures state that the material world must only be the means, not the end of life. The material world will inevitably and eventually cause sorrow, for such is its nature — it changes constantly. Tragedies are signposts directing us towards the true purpose of life, the original purpose of Brahma, the purpose that existed before he sprouted many heads — to truly understand the self.

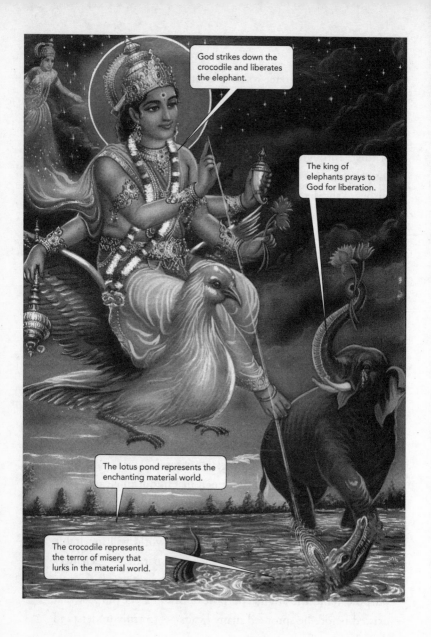

Image 7.11
Vishnu liberating the king of elephants

Image 7.11 shows Vishnu rescuing an elephant from the jaws of a crocodile. That elephant is man who is enchanted by material world. He deludes himself into believing that the purpose of life is name, fame, wealth and power. So he behaves like an elephant enjoying the lotus lake, only to find himself trapped in a crocodile's mouth. The crocodile represents the pain and misery that result when one seeks such pleasures in the material world — the inescapable frustration, the invalidation, the rage and the regret. To be liberated from all pain and misery, one cannot rely on one's own strength. One has to recognise and have faith in that power which is greater than the ego. This power is called God, the divine within. In this image, it manifests as Vishnu.

Thus, all humans have an option — either surrender to our animal nature, the beast within us that seeks to dominate the world around, that uses its strength and cunning only to survive and indulge itself and never fill the vacuum within us or conquer our animal nature and seek the divine within us, understand and connect with the world around through affection and find fulfillment. This idea is best represented through Image 7.12, which shows Hanuman, who, though a beast, is regarded both as god and God.

Hanuman is called Sankat-mochan, the remover of problems. He is worshipped by people in the hope that he will destroy the problems in their lives the way he solved all of Ram's problems. He is the god who can overpower Shani, the lord of Saturn, who delays things. He is the god who can overpower Rahu, the lord of eclipses, who hides things.

Monkeys represent the restless and curious mind. Hanuman is a mind that has focused on God. Ram, as God, rests in Hanuman's heart. And this faith in God has made Hanuman

Image 7.12
Hanuman

powerful. It helps him triumph over the vagaries of fate. It helps him use his free will not to change material reality, but to be patient with it. Hanuman, though animal, is nobler than most human beings. He helps everyone selflessly and does not crave power. He is self-contained in his love for God, which manifests as his love for humanity. He is described as celibate, which means he is unlike Brahma — he does not chase the Goddess in lust. He has no desires and accepts his destiny. He is at the feet of Sita and Ram as shown in Image 6.18, content to serve Goddess and God, material and spiritual reality.

If a monkey can become God, so can man. Thus, there is still hope for Brahma, the unworshipped God.